STRIKING POSES

STRIKING POSES

CREATING A VISUAL DIALOGUE

PHOTOGRAPHS by Max James Fallon

IN DIALOGUE with Barbara Deutsch

Published by

MustSeeBooks

P.O. Box 320186
San Francisco, CA 94132

www.mustseebooks.com

STRIKING POSES

Publisher's Cataloging-in-Publication
(Provided by Quality Books, Inc.)

Fallon, Max James
 Striking poses : creating a visual dialogue /
photographs by Max James Fallon in dialogue with Barbara
Deutsch.
 p. cm.
 LCCN 2005925337
 ISBN 0-9766893-0-8

 1. Portrait photography. 2. Intercultural
communication. 3. Travel--Pictorial works.
4. Travelers' writings--Pictorial works. I. Deutsch,
Barbara. II. Title.

TR680.F35 2006 779'.2'092
 QBI05-600029

Printed in China by Oceanic Graphic Printing

10 9 8 7 6 5 4 3 2 1

Orders, inquiries and correspondence should be addressed to:

MustSeeBooks

P.O. Box 320186
San Francisco, CA 94132
www.mustseebooks.com

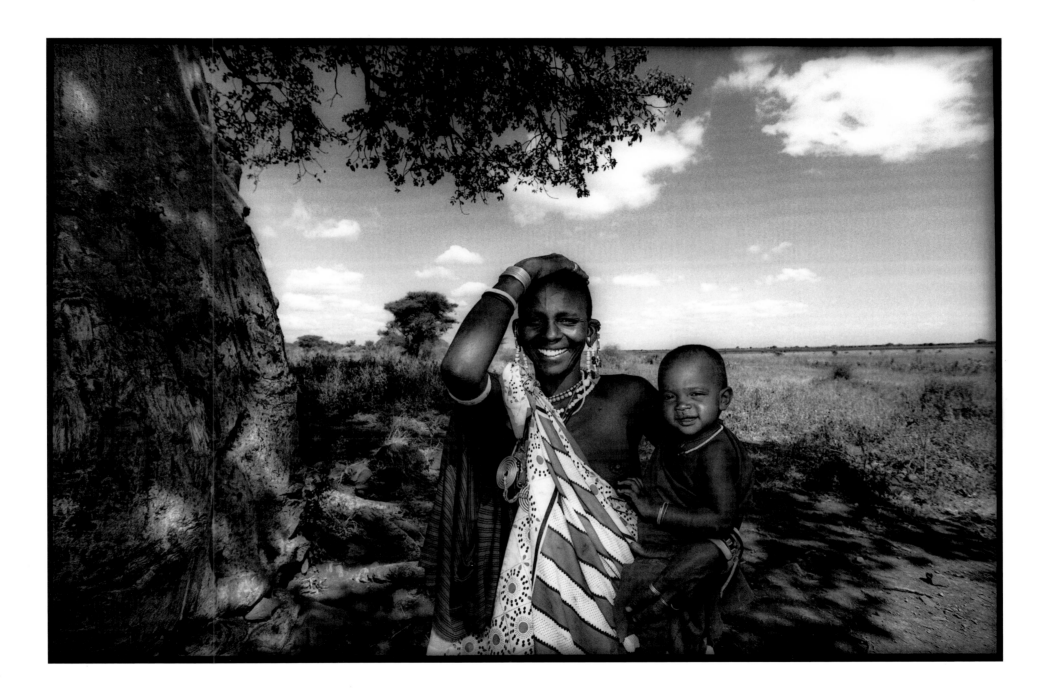

Smiling Mother – *TANZANIA*

STRIKING POSES

For twenty-five years, Max and I have had a two-dimensional friendship.

Whenever we get together, he shows me the photographs he shot on his latest trip. Looking through his portraits inevitably leads us to long conversations about the most amazing range of subjects—culture, politics, economics, justice, beauty, art, human nature, sex, poverty, philosophy, religion.

There's not much small talk between Max and me because his photographs always take us to the bigger picture. Paradoxically, it is the very specificity of Max's pictures that prompts our discussions of the universal.

I also find a fascinating parallel between our conversations and the photographs themselves. Just as our thoughts and feelings spin out from the gaze of the individual before us, so do many surprising, mysterious and sometimes humorous elements in the photograph spin out from the central subject or subjects. As in "real life," what seems at first to be simply a compelling face or two frozen in time soon becomes a complex story with unforeseen twists and turns that shake up our assumptions and ask us to reconsider our initial impression.

Much has been said about photography as a window on the world, but Max and I have found it to be a mirror as well. When we first talked about naming his book "Striking Poses," we liked that the title incorporated the volition of the photographic subject as well as the response of the viewer. This act of choice on the part of the subject has had a deep effect on Max over the years he has been engaging strangers on the streets of Calcutta, Beijing, Soweto, Guadalajara, Cairo and San Francisco. He has found that, regardless of culture or location, occupation or class, the photographic subject always exhibits a strong sense of self, of the specialness of the moment and the importance of his or her place in the world at large. For Max, that split second is one of such beauty and poignancy that it has kept him on the road for nearly two decades.

Of course, there is the other side of the equation—how the photos strike the viewer. Again and again, the portraits have caused viewers to explore and challenge their own assumptions about people and culture—which isn't really very surprising. After all, that is the very reason Max takes the pictures. Not just to communicate with his subjects but also with everyone who sees them. He is sharing a split second of himself as well as that of his subjects. In his choice of people and surroundings, in his composition, even in his printing, he's sharing what he finds valuable, compelling and true.

I think that's why Max and I never get around to talking about restaurants and movies and friends. With the truth staring us in the face, who needs reality?

– Barbara Deutsch

Having spent the last two decades approaching strangers on the streets of the world, I can tell you that globalization—in the broadest sense of the word—is alive and well in every corner of the globe. The people on our planet are connecting and relating and confronting at an unprecedented pace that is accelerating every day. From my perspective, 9/11 hasn't changed that reality one bit. Quite the contrary, it has created an even more compelling argument for each of us to take the initiative and engage with people of other cultures, to share our similarities and learn from our differences—or these differences will be our undoing.

In my experience, the camera—be it a Nikon or a tiny digital—is the perfect instrument of engagement. To photograph people with their consent and involvement requires us to request rather than dictate, to interpret instead of define, to participate as well as observe. It requires no language skills. Its function and purpose is understood by all. And it is the essential antidote for the contrived, inauthentic experience offered at the theme parks and Epcot Centers of the world, where we are encouraged to view every life experience as passive entertainment.

I urge you to get out there and approach someone who interests you, someone with whom you feel, for some reason, a shared humanity. It's as simple as saying, "Excuse me, do you mind if I take your picture?" I think you'll be astonished at the results. I know I always am.

So let's suppose you've taken your camera for a walk, and you've spotted someone interesting, real interesting! He's leaning on his ornate front gate, and you can hear music coming from the house behind him. Other people seem to greet him respectfully as they pass by—his gestures and body language are quite revealing.

A light breeze has kicked up a little dust on the street and the late afternoon sun is making his white shirt glow against his tanned skin. He seems content in his world, and you'd like to be a small part of it. With your camera in hand (you've already figured out the basic settings, right?), you approach him like you would when asking someone for directions. Only this time it's for his portrait. If you can approach him in his own language, all the better—and of course smile and look him in the eye. If he says no, which people do a lot of the time, just keep talking and smiling—he may just decide that you're not some maniac, but someone serious about communicating with your camera. Or not. But if he agrees to pose, thank him and quickly survey the surroundings for meaningful details and natural light that would add to the atmosphere that attracted you in the first place.

After shooting a few frames, you may have attracted a few onlookers. Will they add to the subject or should you politely ask them to move out of the frame? Sometimes these people end up being more interesting than your original subject, so photograph them both, together or separately. You can edit later. If the subject grows comfortable with you and your camera, he might just invite you in to meet other friends or family. This is a chance to really share a bit of their culture: how they relate to others around them, their home or workplace, religious icons—all the endless details that say so much about an individual's culture. (You may forget that you're supposed to be photographing!) This is no time to be shy!

Offer to send them prints of the photographs you've just shot. It'll make a big impression on people who may never have had a photo of themselves, or, even if they have stacks of albums, they'll remember you and your camera forever.

— Max Fallon

Photography is essentially a dialogue.

*Between photographer
and subject.*

*Between photographer
and viewer.*

*Between viewer
and subject.*

*And for me especially,
between the photographer
and the entire world.*

*That's why each photograph
in this book is captioned
with bits of conversation I've
shared with a friend who
finds my photographs a
great way to jump-start new
ideas about everything from
aesthetics to Zen.*

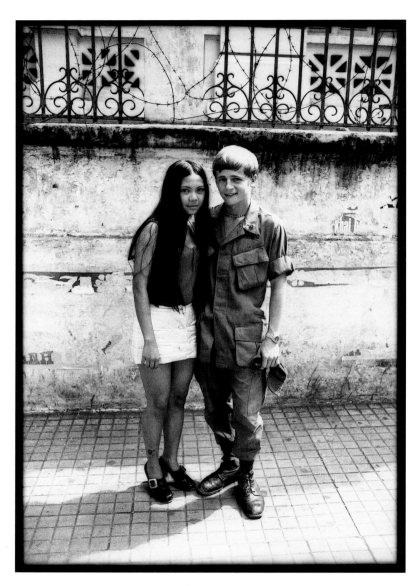

This 1970 photo—which was to become the prototype for all the STRIKING POSES photos that follow—encompasses even more dialogues than usual. In addition to those of the subject, photographer and viewer, there are dialogues between two young friends, two different cultures and two nations at war.

Here's my challenge to you:

START thinking of your CAMERA
as an extension of your PASSPORT, as a
visual VISA—that enhances your ability
to have a more meaningful dialogue with your fellow
world citizens. USE your camera to really CONNECT
with people—in your own environment
or on the other side of the globe.

"Too often, the miracle of photography is taken for granted. Find a subject, point and shoot —from a safe distance of course. But taken seriously, a photograph is an intimate and emotional communication between subject and photographer, then photographer and viewer."

Max

BD: Max, this shot is endlessly fascinating to me—the three entirely different moods on their faces. From left to right—joy, curiosity, pride.

MAX: The mother was filled with pride for her daughter. She wasn't sure why I chose to photograph them, but she offered all she had for the camera—and it shows.

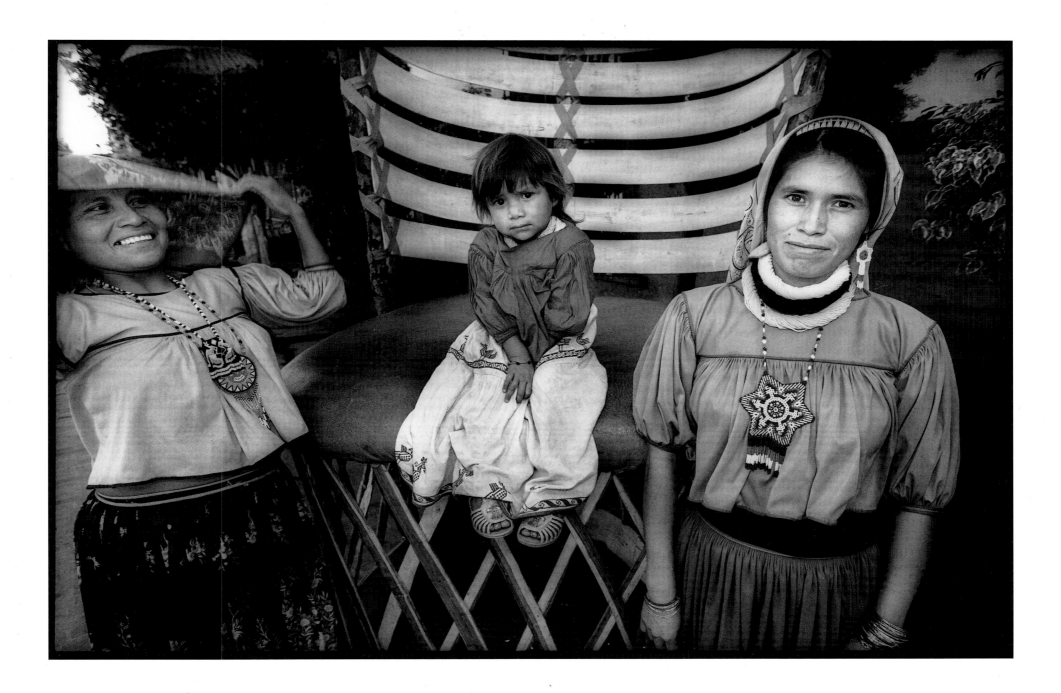

Girl on Chair, Tlaquepaque – *MEXICO*

"Finding visual beauty and order in a rather chaotic world is a worthwhile goal." Max

BD: I love this, Max. To me, it asks the question, "What endures?" Is it a gorgeous monument? Or the pageant of human life, generation after generation after generation?

MAX: This man's face is the reason I take pictures. The eye contact, the humanity. His thoughts are impenetrable, but I continue to wonder what he's thinking about, what matters to him in life.

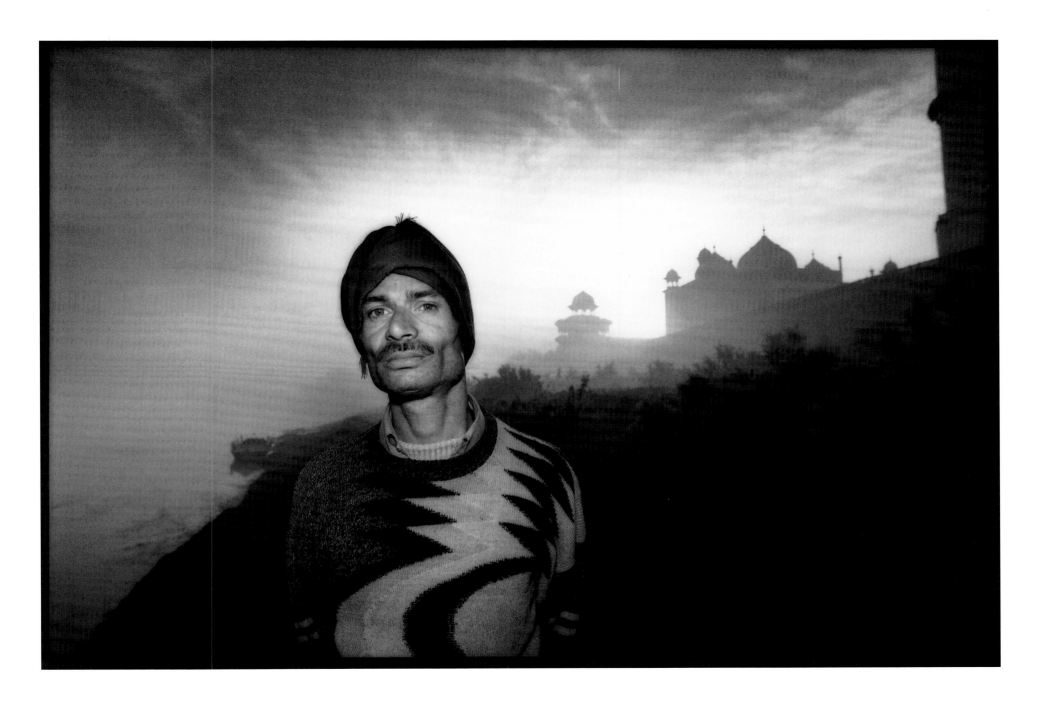

Sunrise Behind the Taj Mahal – *INDIA*

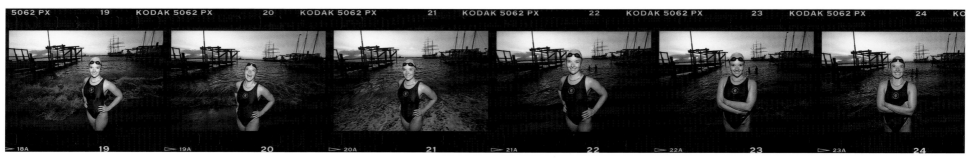

MAX: This is one of the few portraits I've taken with no mystery or ambiguity. Her story is written in her smile. I like to look at this photo when I'm being indecisive. She says to me, "Plunge in and live. That's all that really matters."

BD: I see her as a prototype for everyone who is lucky enough to have found a passion. She's proud, confident, comfortable, happy to share herself with you. Max, it could just as well be you standing in front of your darkroom.

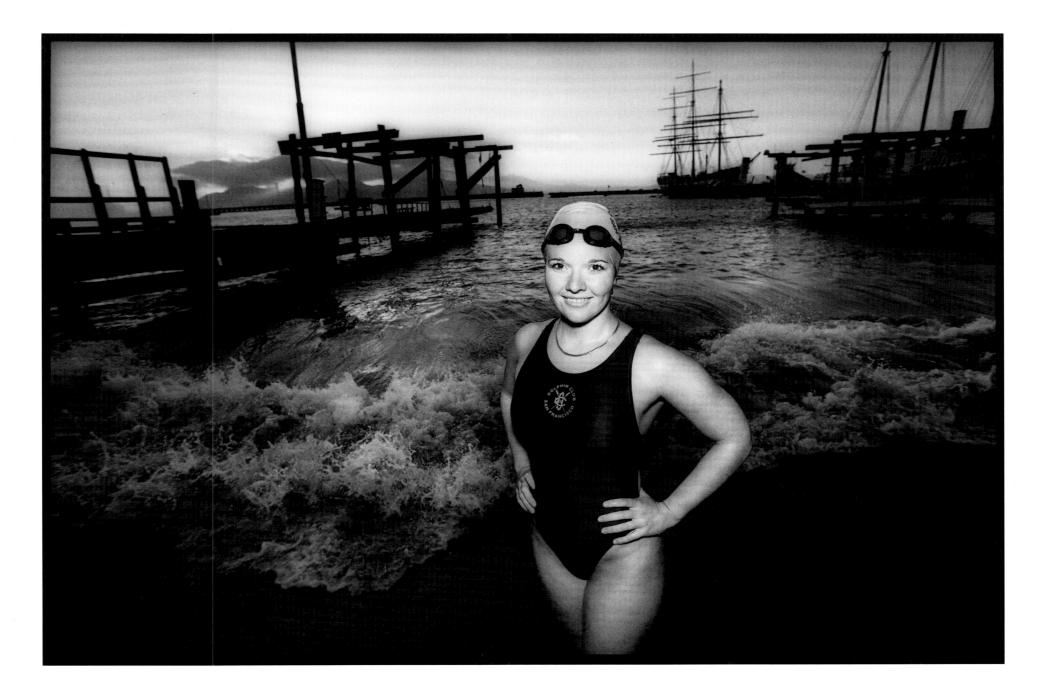

Long Distance Swimmer – *SAN FRANCISCO*

"...the British Empire **in one shot!**"

MAX: It's the history of the British Empire in one shot! Except this time the colonized have landed on the colonizer's soil.

BD: There's the English architecture, the symbol of military might, the former colonial subjects. I just wish I knew what's going through their minds.

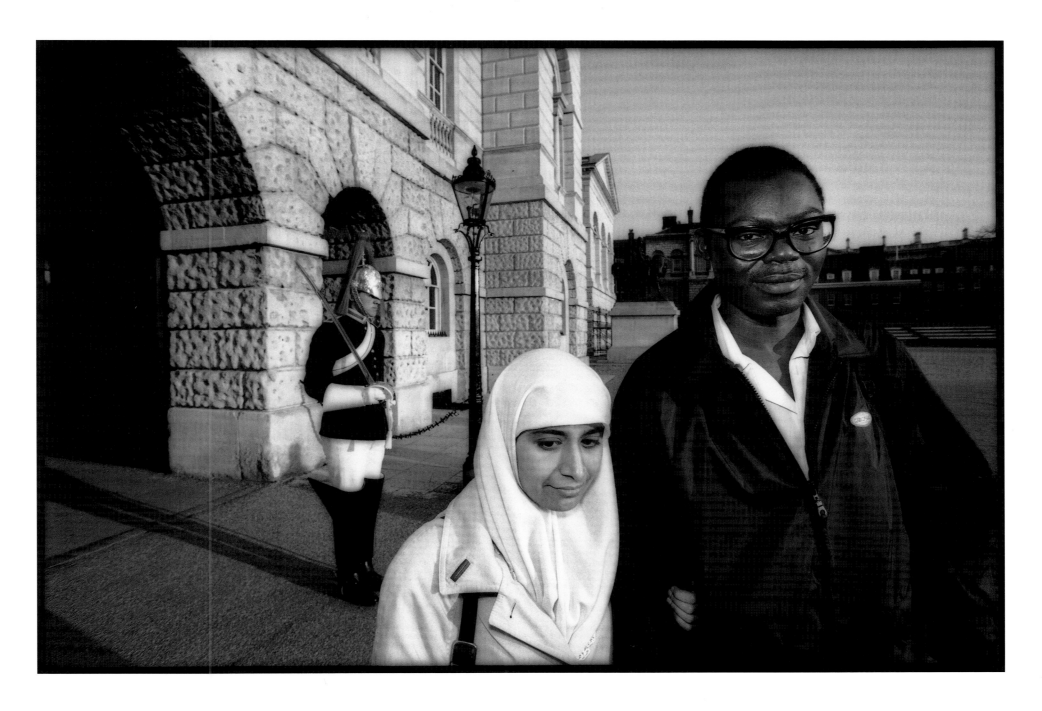

Tourists Posing with Guard – *LONDON*

BD: I've got an instant story about this guy. His parents emigrated to New York and it's his job to fulfill the American dream for his family. But now that he has his MBA, suspenders and Wall Street Journal, he's not so sure if he wouldn't be happier running a seaside café on the Mediterranean.

MAX: Good question. Maybe he should turn around and ask George Washington.

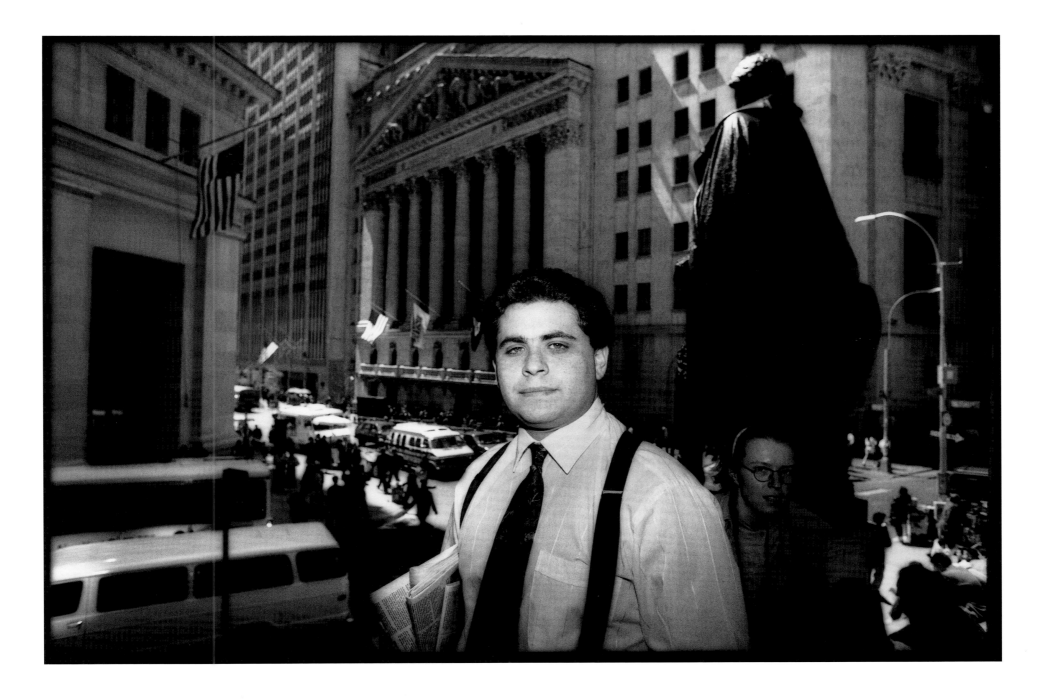

Wall Street – *NEW YORK*

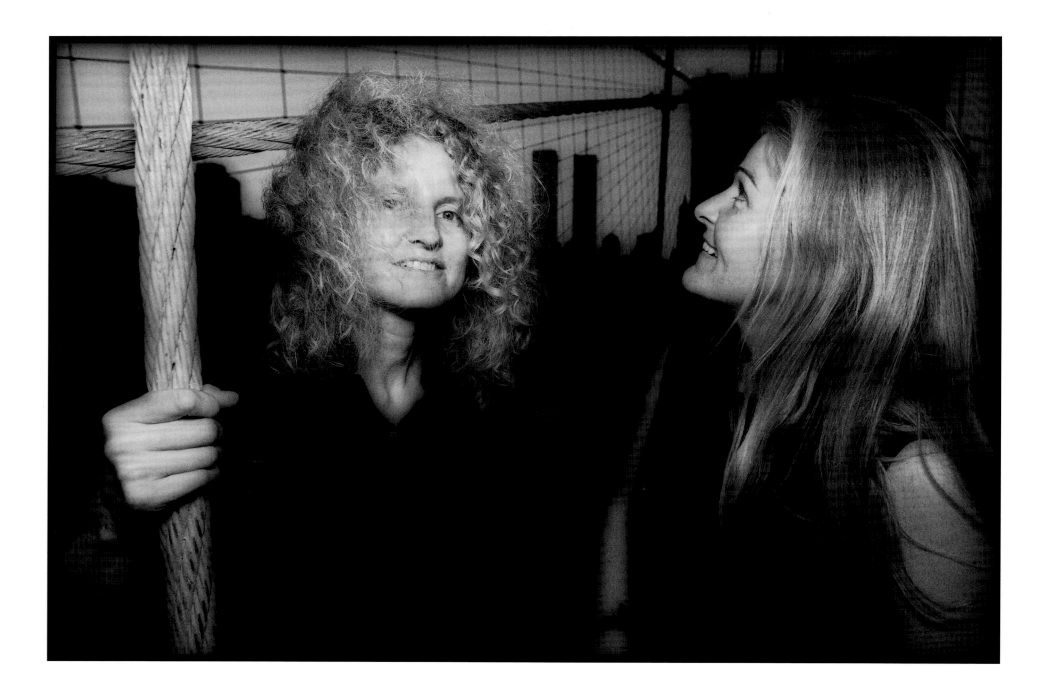

Brooklyn Bridge View – *NEW YORK*

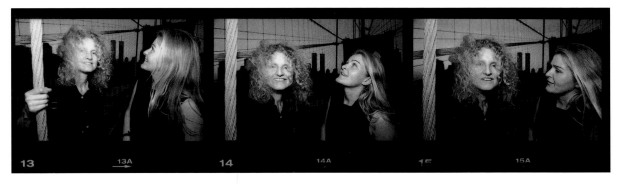

MAX: When I shot this, I was totally absorbed by the beautiful Brooklyn Bridge at dusk and the delightful German tourists—not the World Trade Center in the distance. I imagine there are countless photos like this that are now infused with sadness and irony.

BD: Off in the distance, the towers look like some ghastly premonition of what the future holds. It's chilling.

"I want to go there right now."

BD: At first glance, one might be reminded of a Diane Arbus photograph, but to me, this is the polar opposite. These men aren't oddities. They have too much pride in their profession and themselves.

MAX: Everything was beautiful there—the people, the lovely architecture, the sky with birds in flight.

BD: I want to go there right now.

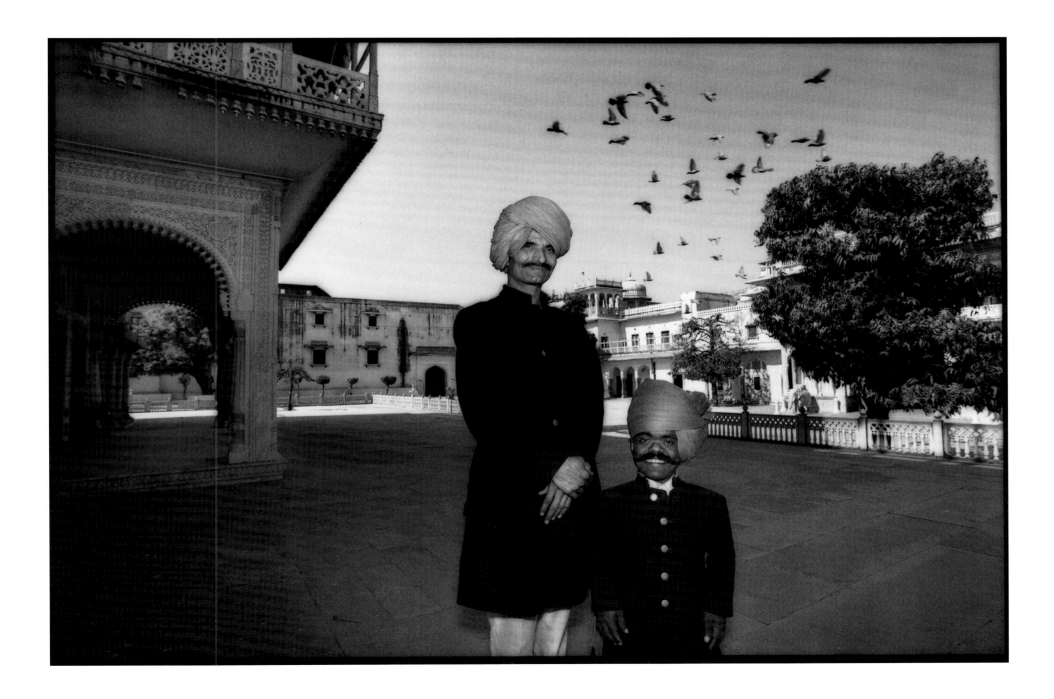

Jaipur Palace Guards – *INDIA*

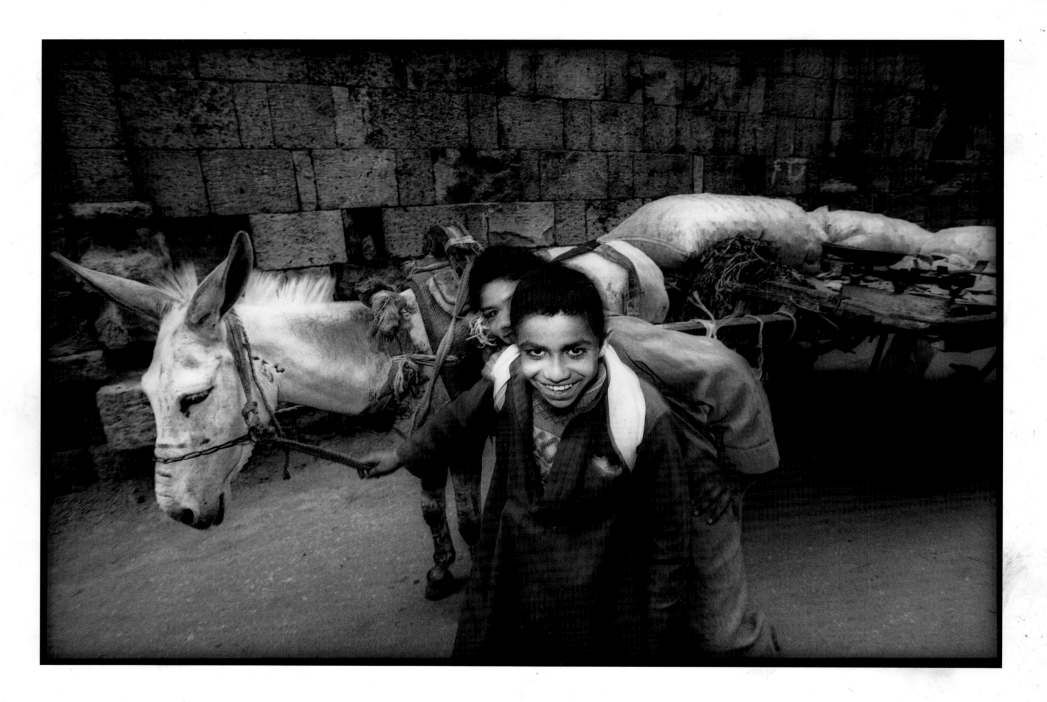

Two Boys in Cairo – *EGYPT*

"...time travel from the twentieth to the twelfth century."

MAX: I noticed these boys turn off a busy Cairo street and followed them into a narrow alley. As their environment changed, they seemed to time travel from the twentieth to the twelfth century.

BD: After all the photos we see of sad-eyed children from the "Third World," it feels good to see these poor children looking happy, healthy and well-fed.

MAX: I connected with this guy instantly. After we discussed the problems of the world and other issues, he insisted I ride back to his farm where he gave me a very used "lucky" horseshoe as a gift.

BD: What a charmer. Sometimes it seems easier to bond with a stranger from another culture than someone in your own family.

MAX: He was no stranger. He was Irish. We share genetic material!

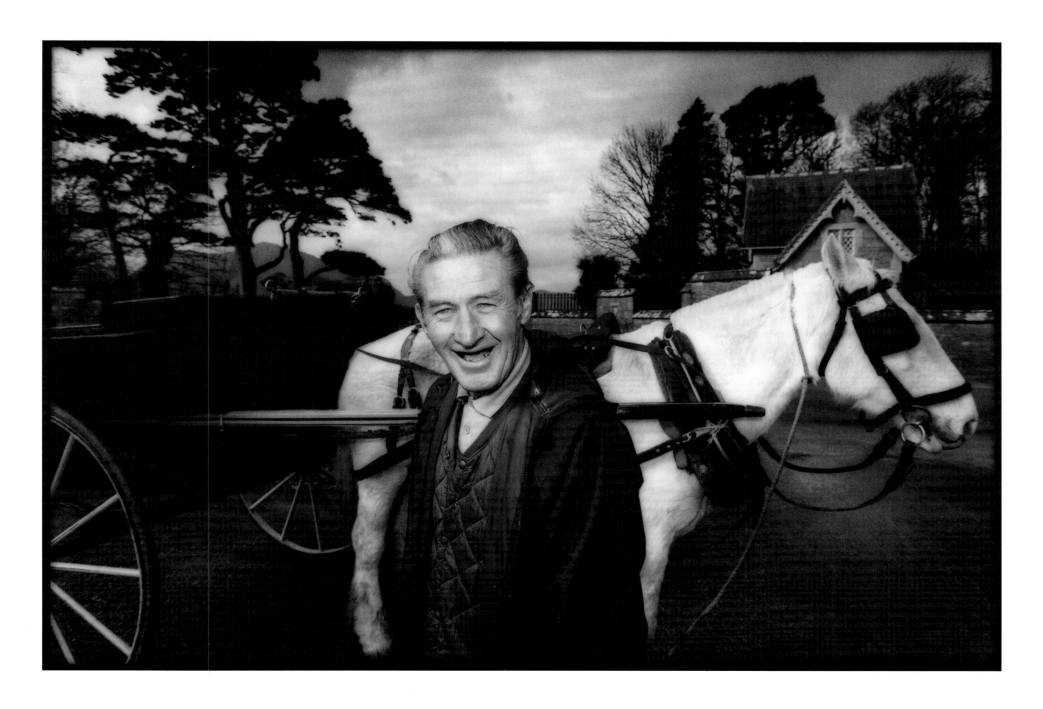

Laughing Horseman – *IRELAND*

"I have a strong need to know these people, not from a safe distance, but up close where I can see their eyes and maybe a revealing facial expression. I'm trying to communicate to them that I'm genuinely intrigued. I do this by asking for a moment of intimacy— a photograph of them in their own environment."

Max

MAX: It was the classic photographer's dilemma. What is the point of going all over the world taking pictures? This family is desperately poor. It certainly wasn't helpful to them to be photographed.

BD: Maybe your photograph will help us recognize the individuality and personhood of those outside our usual sphere of concern. That has value—and it can motivate us to take action.

MAX: It's nice to think so.

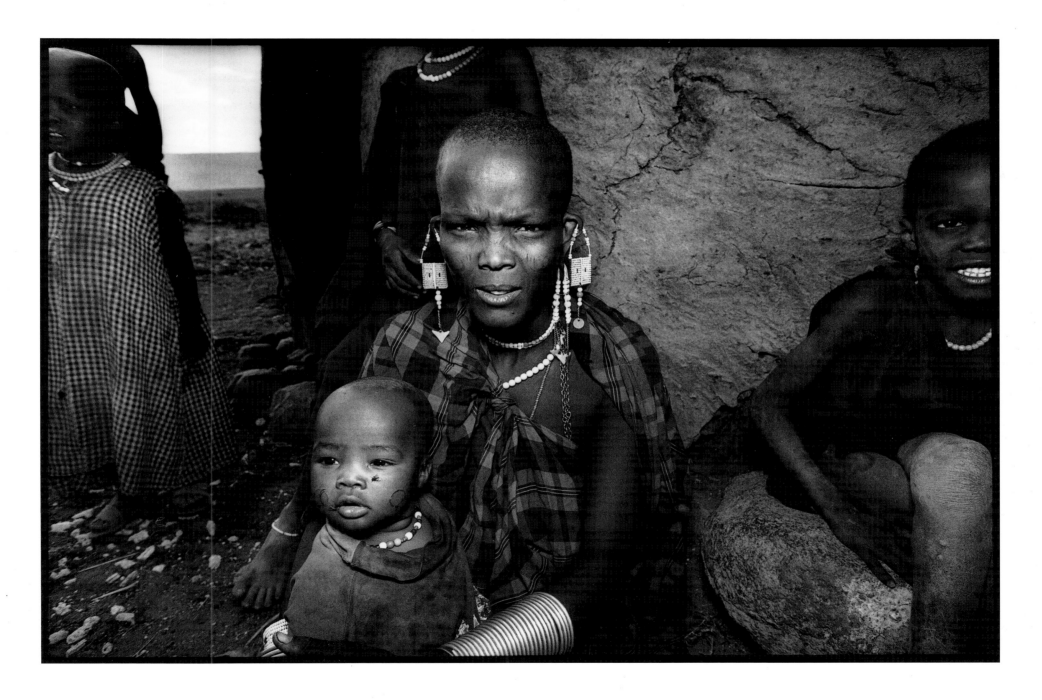

Mother with Children – *TANZANIA*

MAX: Are these lads Irish or what?

BD: Perfect stereotypes in every way. It makes you wonder what to make of stereotypes. You can't deny they're rooted in reality. But before long, we're using them to close our eyes to the complexity that lies beneath. It's dangerous but very convenient.

MAX: I don't think these men give a moment's thought to any of that. They're unconsciously and proudly Irish. It's who they are.

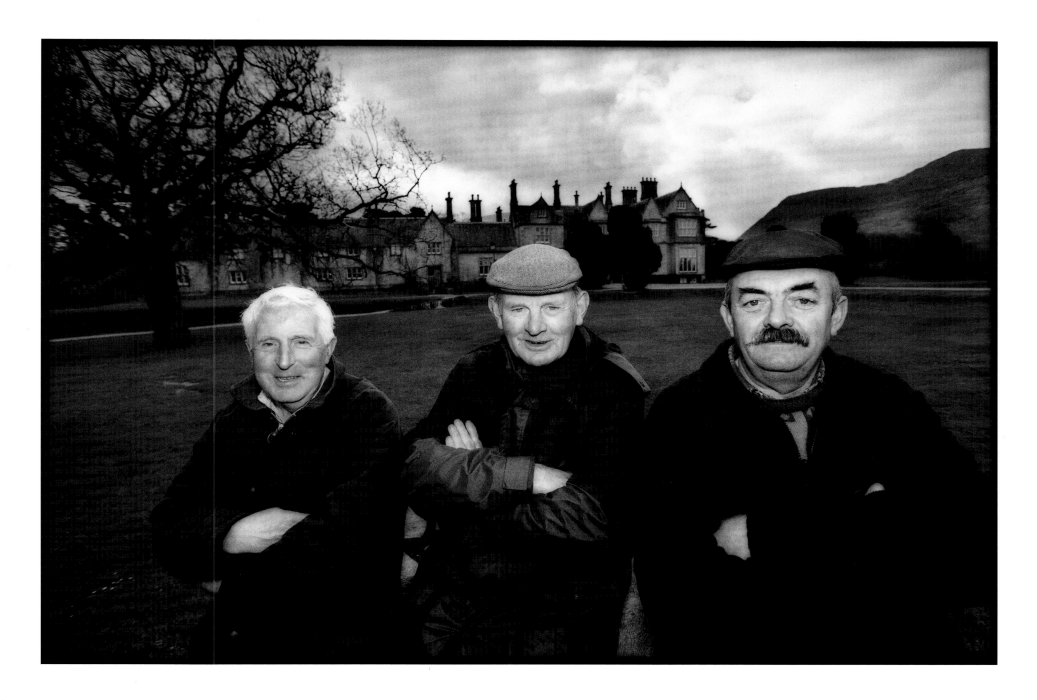

Muckross House, Killarney – *IRELAND*

"...ultra-orthodox yucking it up..."

BD: I've never seen a picture of ultra-orthodox yucking it up like this.

MAX: Tell me about it. They frown upon outsiders taking their pictures, and I approached people in Mea Shearim for about six hours before these men suddenly agreed to pose. I got the feeling that they were laughing because it felt good to "be bad."

BD: The rules change from culture to culture but human nature doesn't. It's liberating to break the rules now and then.

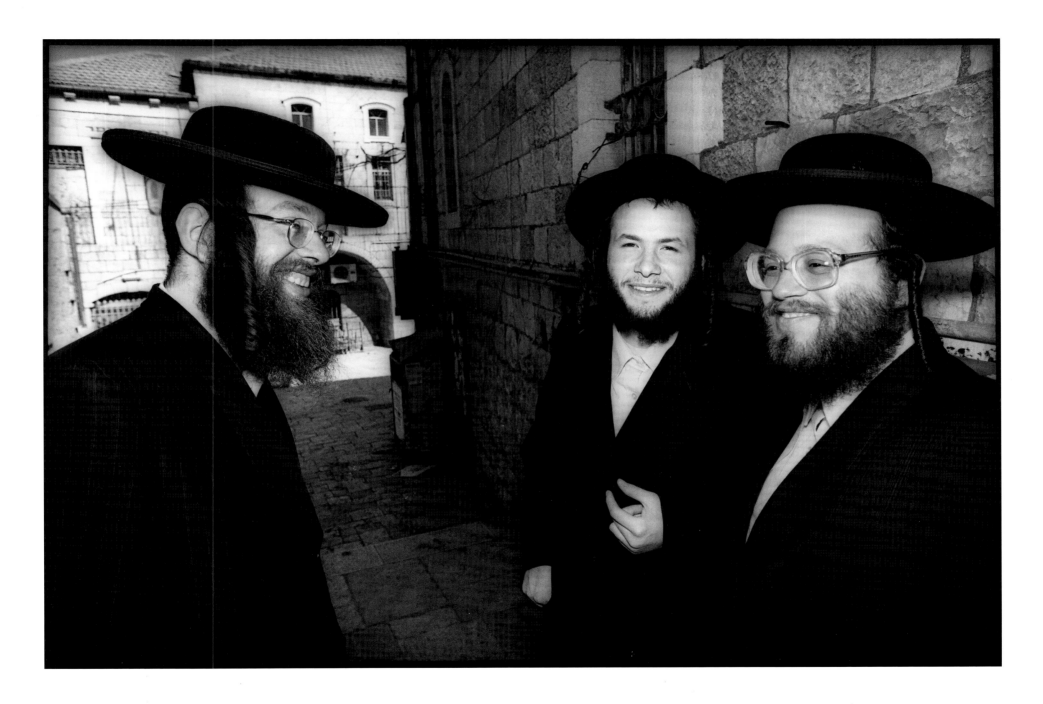

Three Men in Mea Shearim – *JERUSALEM*

"This amazing tool is all about sharing. It makes it permissible for us to approach strangers who interest us, then collaborate with them to produce a meaningful image. Later, we share the results with others, hopefully to stimulate their curiosity and emotions about their fellow human beings."

Max

MAX: I can still remember the smells and the muffled sounds as I made my way through Varanasi that morning just before sunrise on my way to watch the Hindu faithful immerse themselves in the timeless Ganges.

BD: Who are these men with the intense gazes?

MAX: They're Hindu holy men and vendors of sacred offerings for the arriving pilgrims.

BD: The photo could be a thousand years old—if there was photography then!

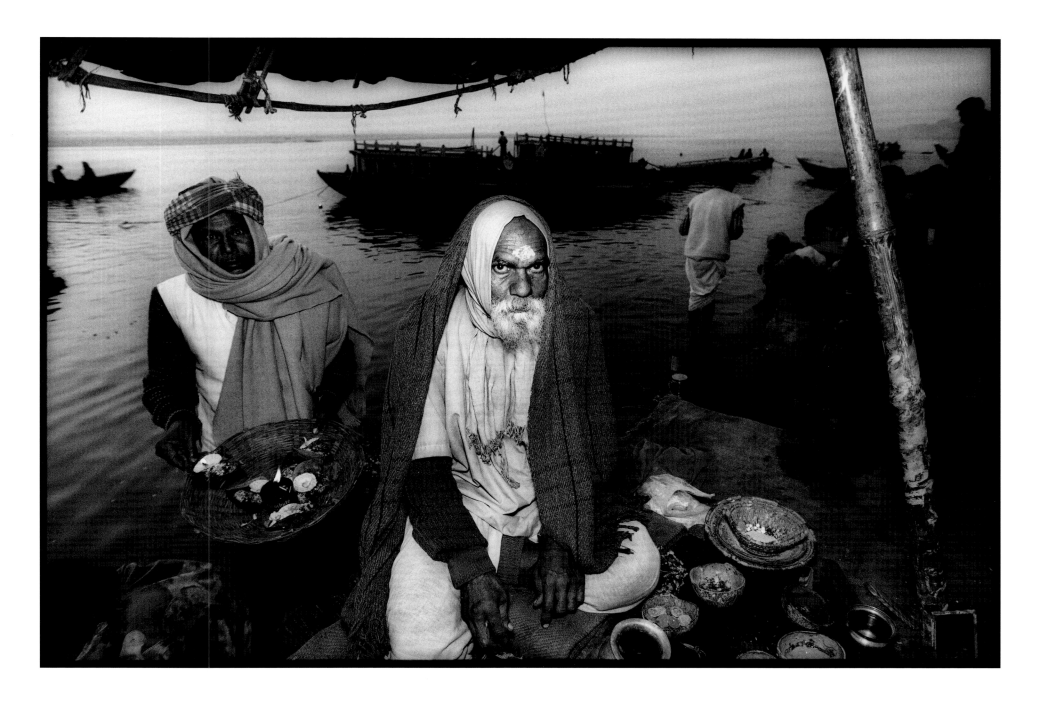

Dashashwamedh Ghat, Varanasi – *INDIA*

MAX: This annual fair is the most over-the-top event, even for San Francisco. I always wonder what these people do during the week.

BD: I have no doubt that they're bank tellers or insurance salesmen. I don't believe this kind of behavior reveals a true Bohemian spirit or anti-establishment sensibility. It's not thoughtful enough. I think it's just a hobby, like collecting stamps or square dancing.

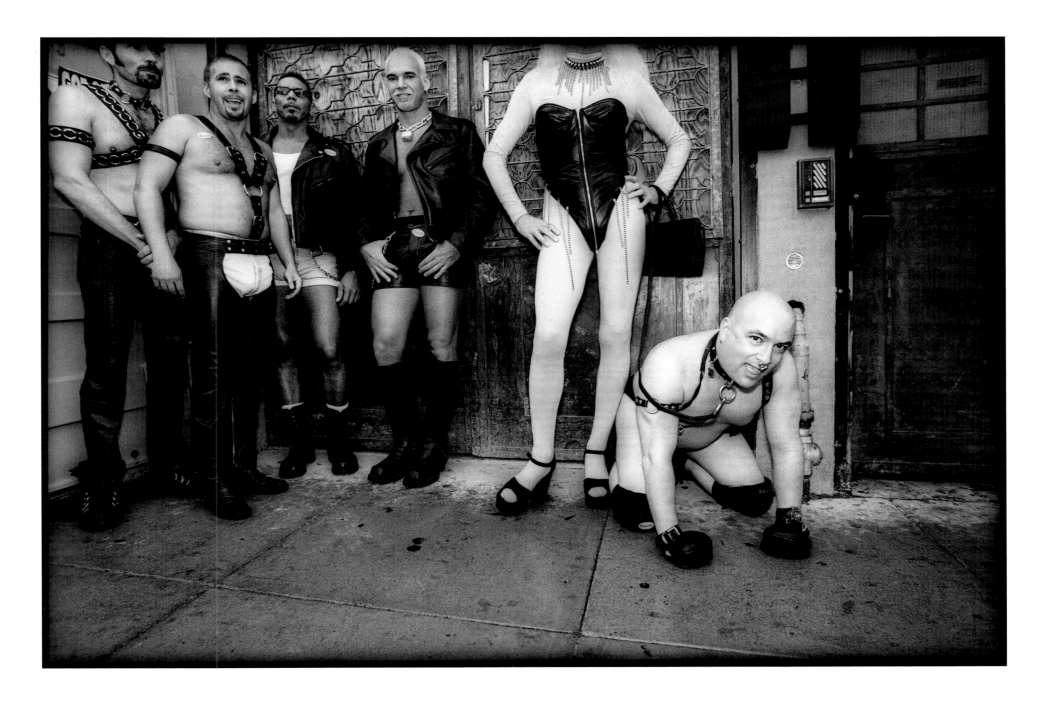

Folsom Street – *SAN FRANCISCO*

"...the **viewer** makes the connections..."

BD: This photograph lets the viewer make the connections in the picture, which, to me, is a crucial part of the art form. I think if you used words to compare the confinement of the woman and the freedom of the child, it wouldn't be effective. But when the viewer gets to participate, everyone is connected—the photographer, the viewer, the mother and the child.

MAX: The mother was so proud of her son—and delighted to be there with him at the playground.

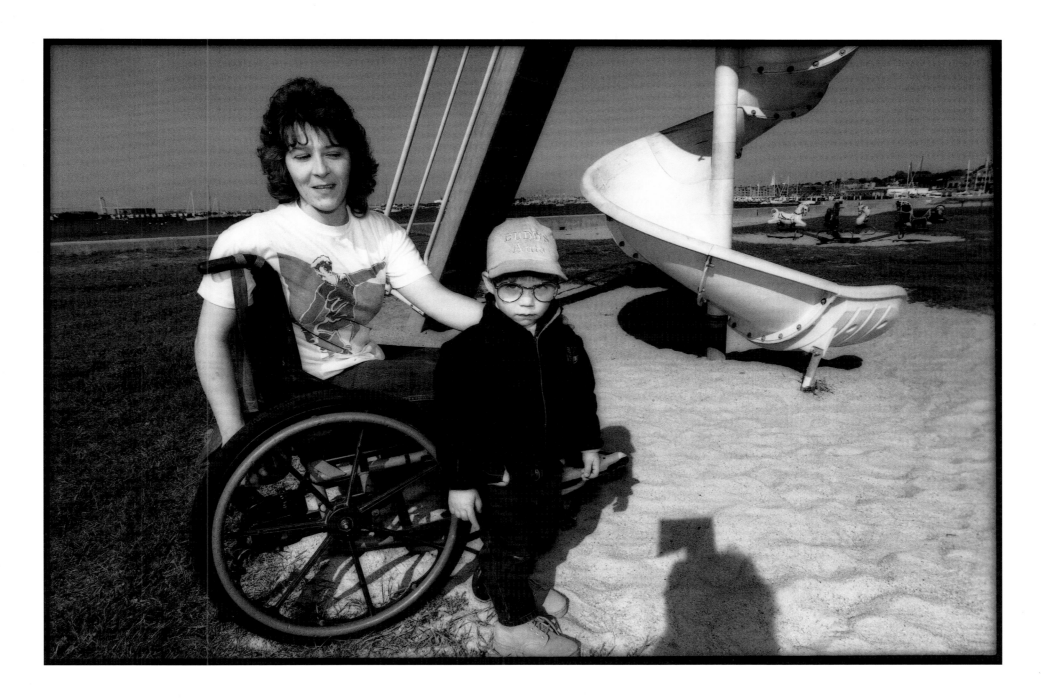

Mother and Son – *RHODE ISLAND*

"Put yourself out there. Use your camera to get into people's faces. Really look at them. Life is too short to miss out on your fellow inhabitants of the planet—their personalities, their families, their environment, their cultures. Touch them with your camera and yourself."

Max

BD: My first thought is of the Greek masks of tragedy and comedy. The father's face conveys so much strength, dignity and life experience, while the little boy, so innocent of life's bittersweet nature, just mugs for the camera.

MAX: And his piglets, of course, a visual element I couldn't resist!

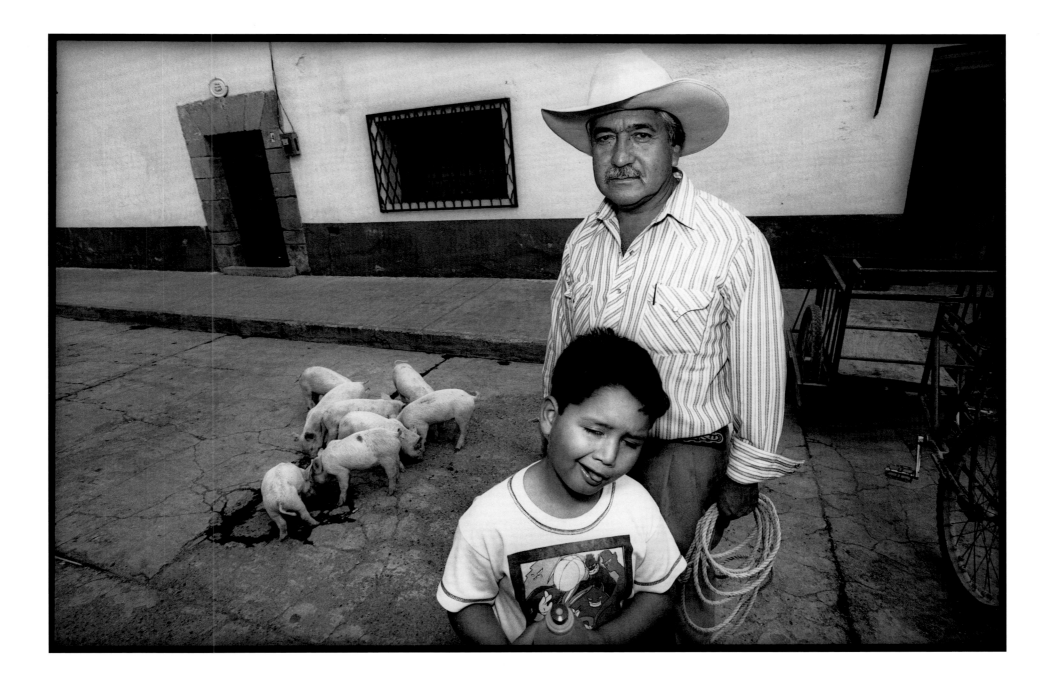

Rancher with Boy – *MEXICO*

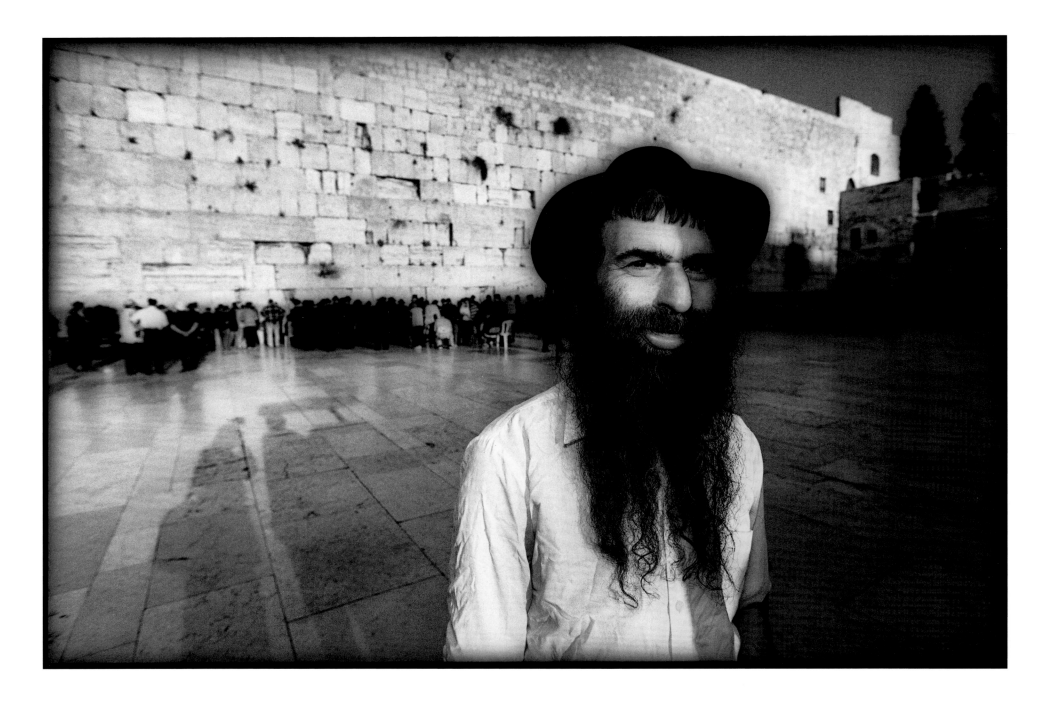

Western Wall – *JERUSALEM*

MAX: It's unheard of for an orthodox to pose for a picture, let alone smile. But again, I think he saw an opportunity to present himself as an individual, not a type—and it was important to him.

BD: He locks me in with his eyes. Thanks to this photo, I see a person, not just a religion.

BD: There's a whole fantasy in one shot—the girl, the beach, the ocean, the surf.

MAX: That's Australia for you. More than California, more than Hawaii, it's the apotheosis of everyone's tropical dream.

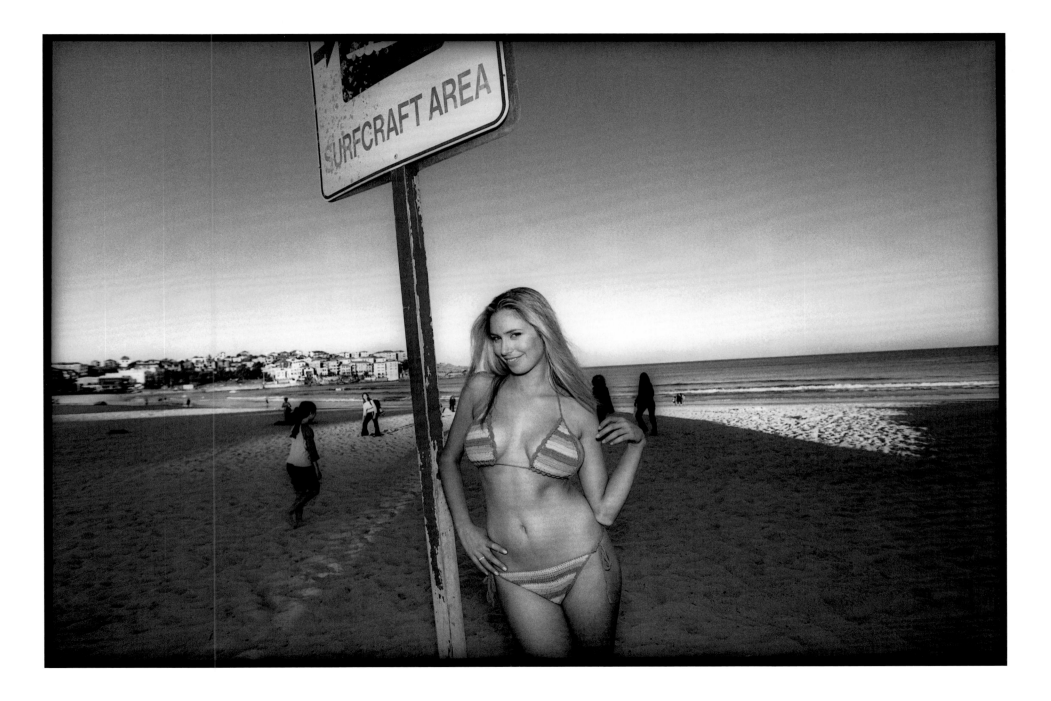

Bondi Beach at Sunset – *AUSTRALIA*

BD: This is the ultimate example of our co-opted consumer society. There is no such thing as true rebellion anymore. It's all about money.

MAX: I suppose it beats sitting in front of a computer eight hours a day. I thought it was pretty creative. Give the tourists exactly what they come to San Francisco for.

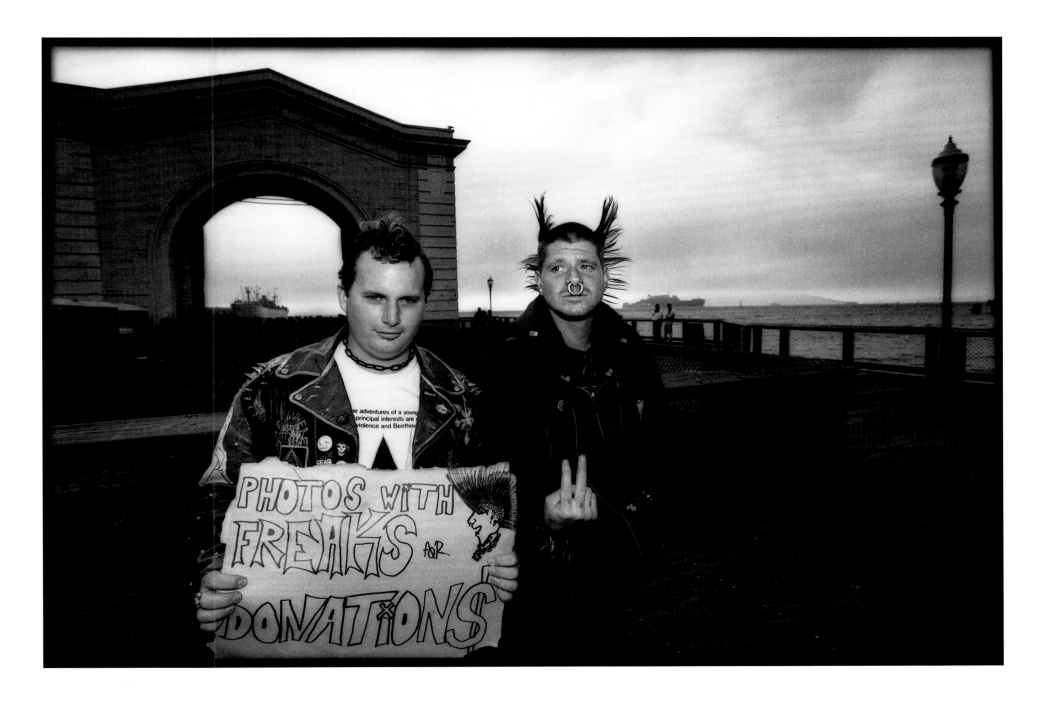

Photos with Freaks – *SAN FRANCISCO*

"Who cares if they look like tourists."

MAX: Is it sad that civilization's most magnificent achievements are now just another tourist destination? Or is it a triumph that they're still appreciated after 3,500 years?

BD: I think it's thrilling. These people have crossed the world to see these treasures. Who cares if they look like tourists. At least they cared enough to come.

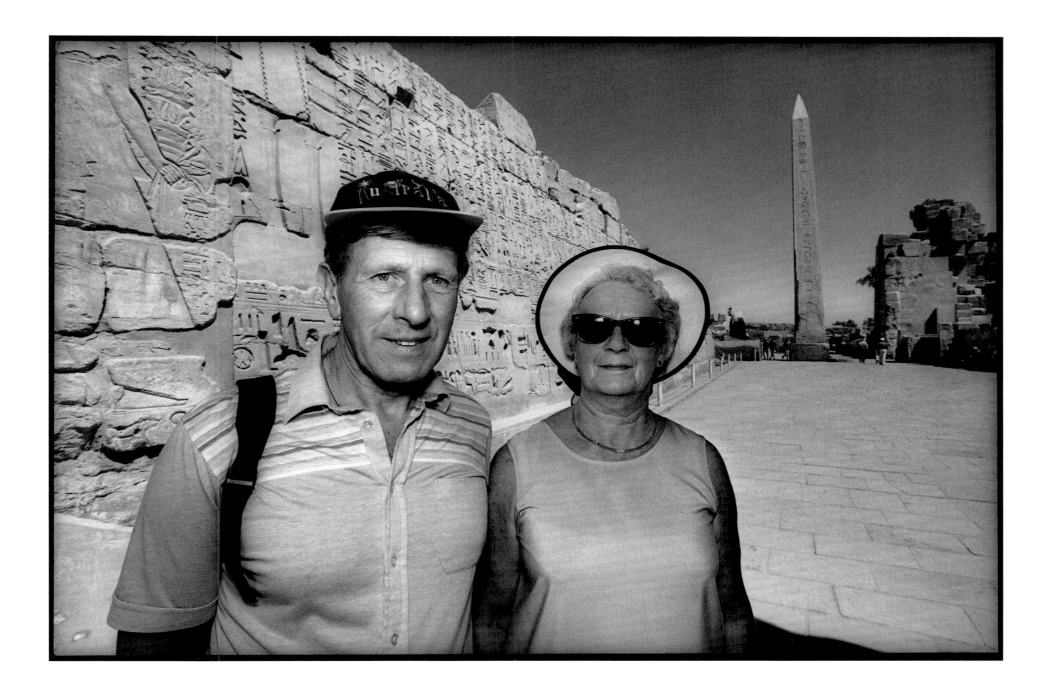

Tourists at Karnak — *EGYPT*

MAX: These kids were like walking poetry, each using one word to make their individual personal statements.

BD: What word would you put on a T-shirt to describe yourself, Max?

MAX: Curious.

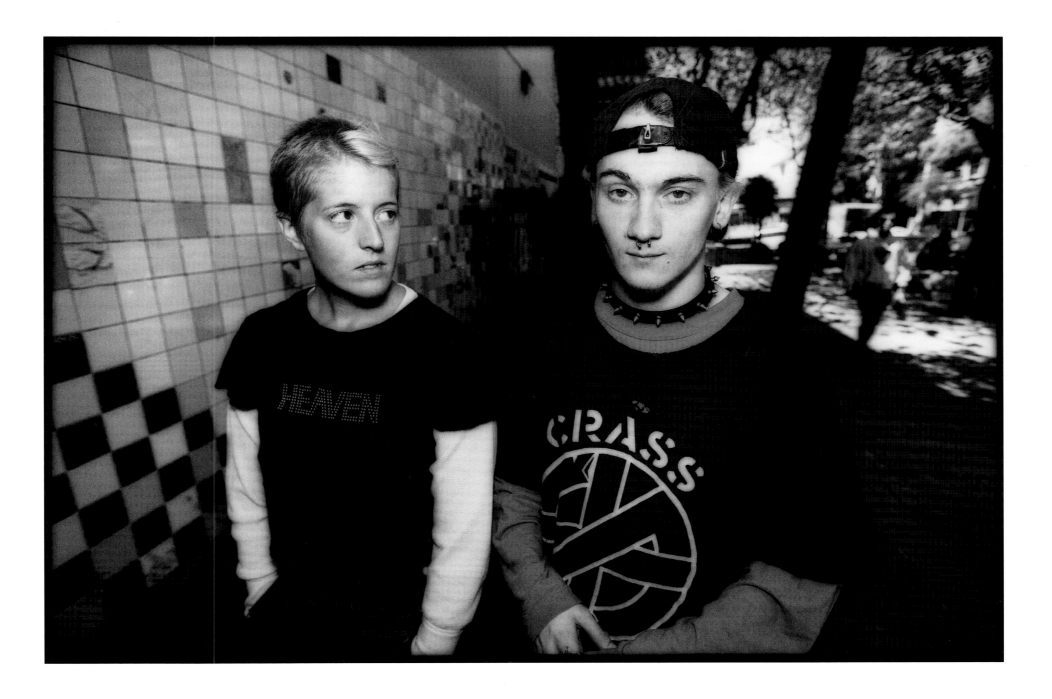

Haight Street – *SAN FRANCISCO*

"...the **tyranny** of good taste."

BD: I once heard an expression—the tyranny of good taste. Good taste tells us that mobile homes and gold chains are tacky, but I've never seen two people who look more charming, warm and, yes, elegant.

MAX: They were French Canadians, just arrived in Florida for the winter. My French couldn't keep up to theirs, nor their English to mine— but we communicated none the less.

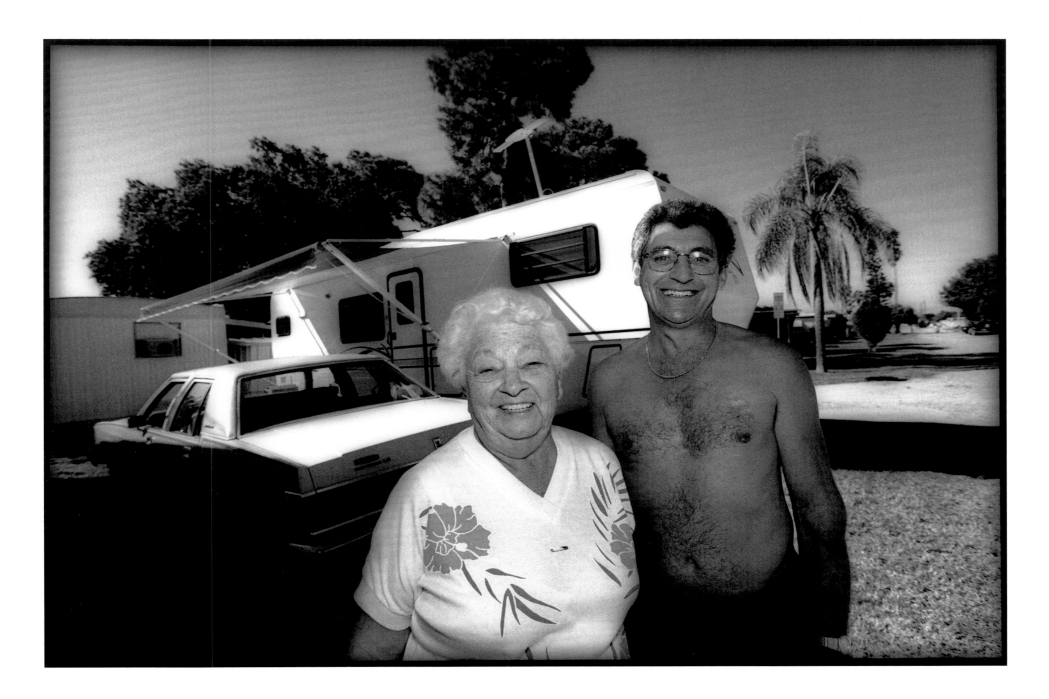

Quebec Grandmother – *FLORIDA*

"Your camera gives you a choice: you can either be a passive observer or an active participant. Guess I don't have to tell you which one I recommend." Max

BD: What could possibly be more compelling to look at than the Taj Mahal? The human face. His soulful, enigmatic expression is actually more fascinating than one of the world's wonders.

MAX: Reality check. A wonderful face, yes, but see the guy on the left? He and his associates were trying to steal my camera bag, so I started photographing them in defense as I walked backwards to extricate myself from this decidedly non-tourist area.

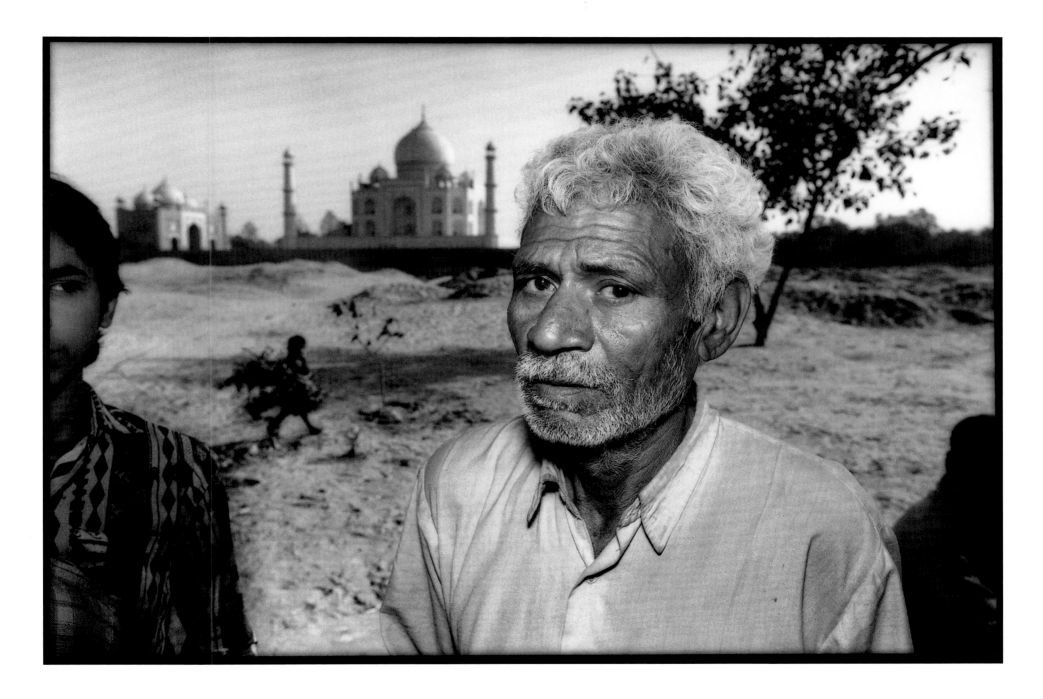

Man in Agra – *INDIA*

"Is it a crime scene?"

BD: I love this because I don't have a clue what's going on. Is it a crime scene, a commercial shoot, a photographer whose car broke down, a dead person's car being shot by a police photographer?

MAX: They're preparing to mount a camera on this Porsche for an advertising photo shoot. Not the most interesting answer, but at least nobody died.

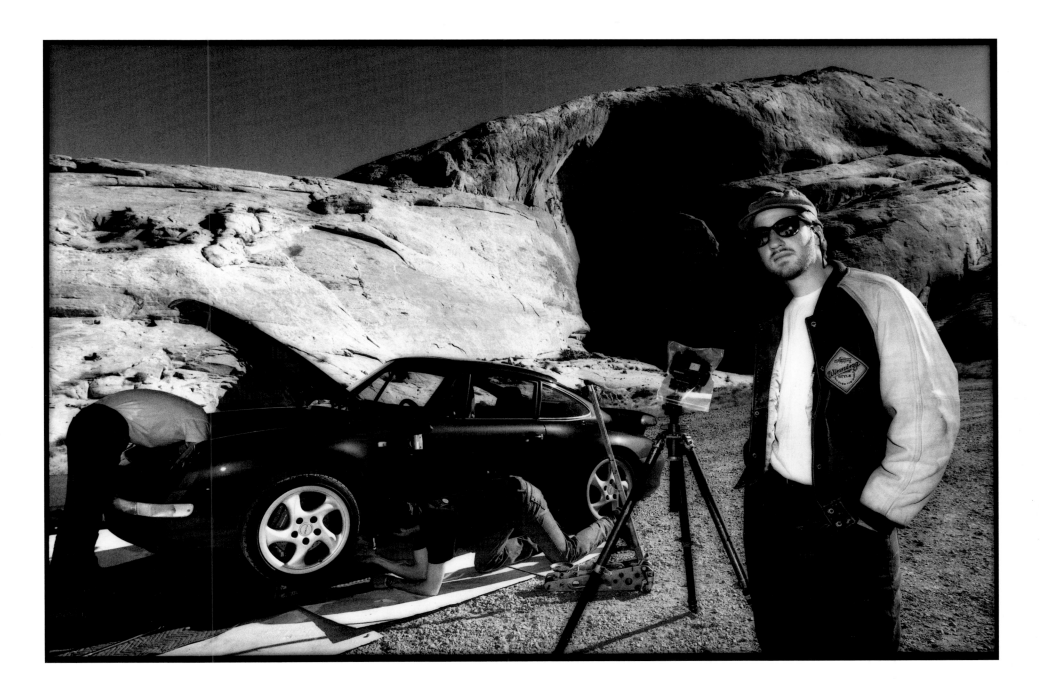

Valley of Fire State Park – *NEVADA*

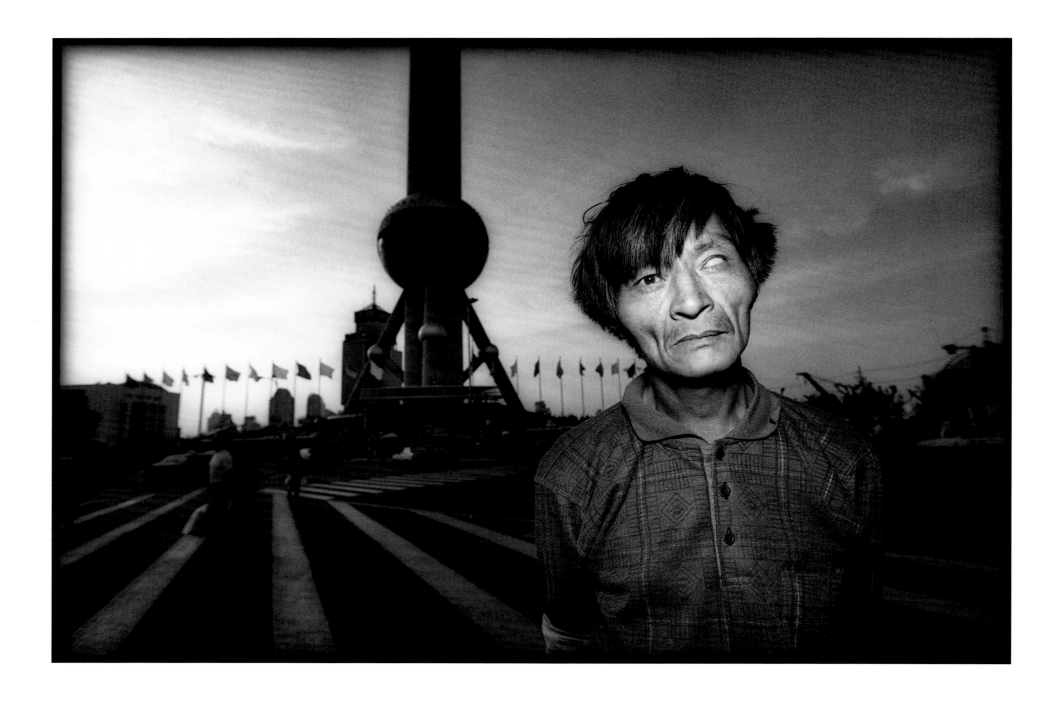

Man in Pudong – *CHINA*

"People seem willing, in most cultures, to pose for my camera without really having time to consider that request. They seldom ask who I am, what I'm going to do with the picture, why I choose them? They're surprisingly willing to take a chance for one short moment in the spotlight."

Max

BD: I'm amazed by the neutrality of his gaze. Our culture uses prosthetics, glass eyes, dark glasses, anything that makes us all the same, liked and accepted. But this man has no concern about his blind eye, neither shame nor pride. It just is.

MAX: When I took the shot, I felt like he was looking at me with both eyes, but in two very different ways. He's viewing his rapidly changing culture with only one eye—his other eye is blind to his culture's history.

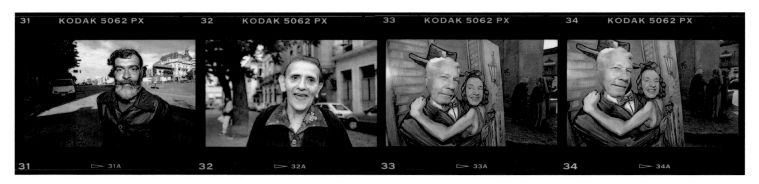

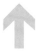

BD: At first, the couple looks so goofy, but then the picture seems very wistful, like a time-lapse film that shows them old and young at the same time. Life is short, you know.

MAX: I'd been talking to the nuns in the background about photographing them when I noticed this situation. Sometimes a quick "Plan B" works out!

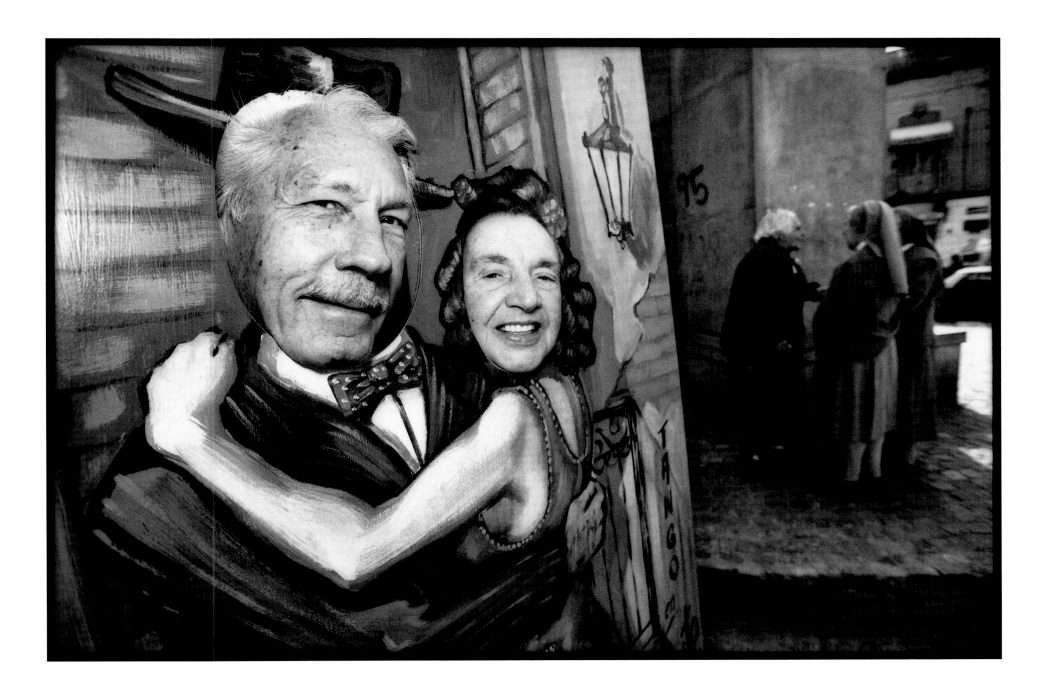

La Boca, Buenos Aires – *ARGENTINA*

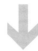

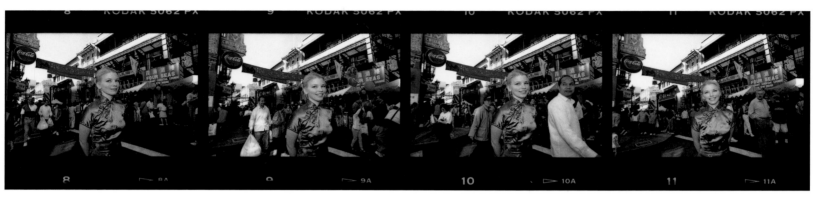

BD: This picture is more San Francisco to me than the Golden Gate Bridge. The back and forth of the Caucasian girl in a Chinese dress and the Chinese man looking at her is priceless, mirrored by the juxtaposition of the Chinese food and Coke signs. And of course, the fact that they're on Commercial Street says volumes. San Francisco has always been a global economy. Now the rest of the world is catching up.

MAX: It was a very yellow dress and she was very Norwegian—she really stood out in the crowd!

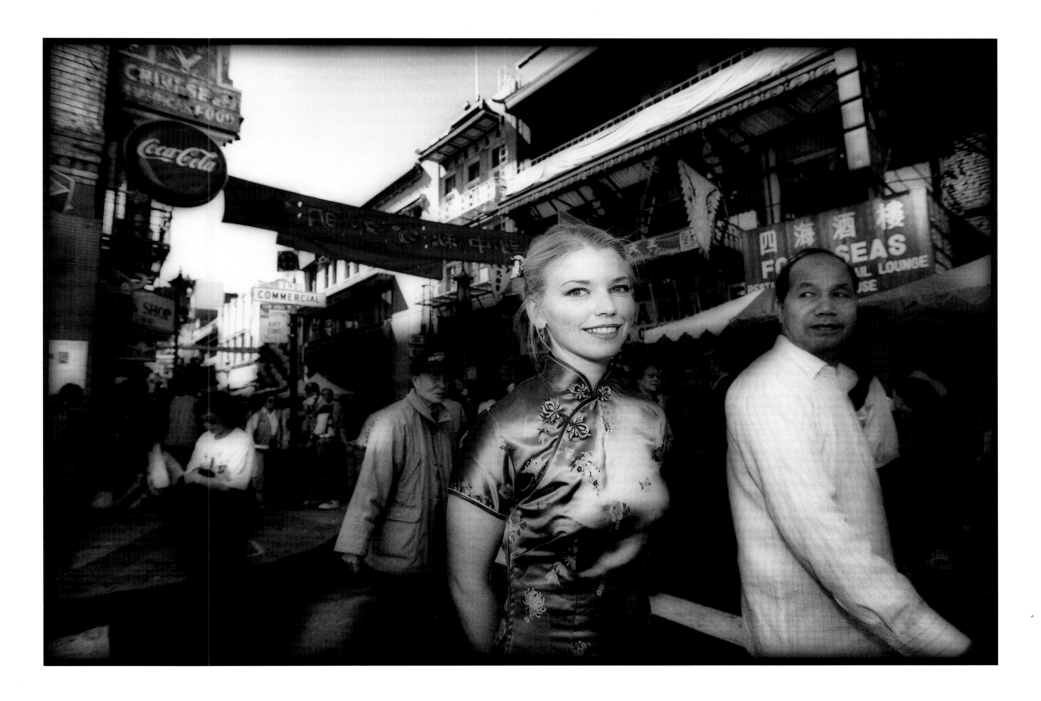

Norwegian in Chinatown – *SAN FRANCISCO*

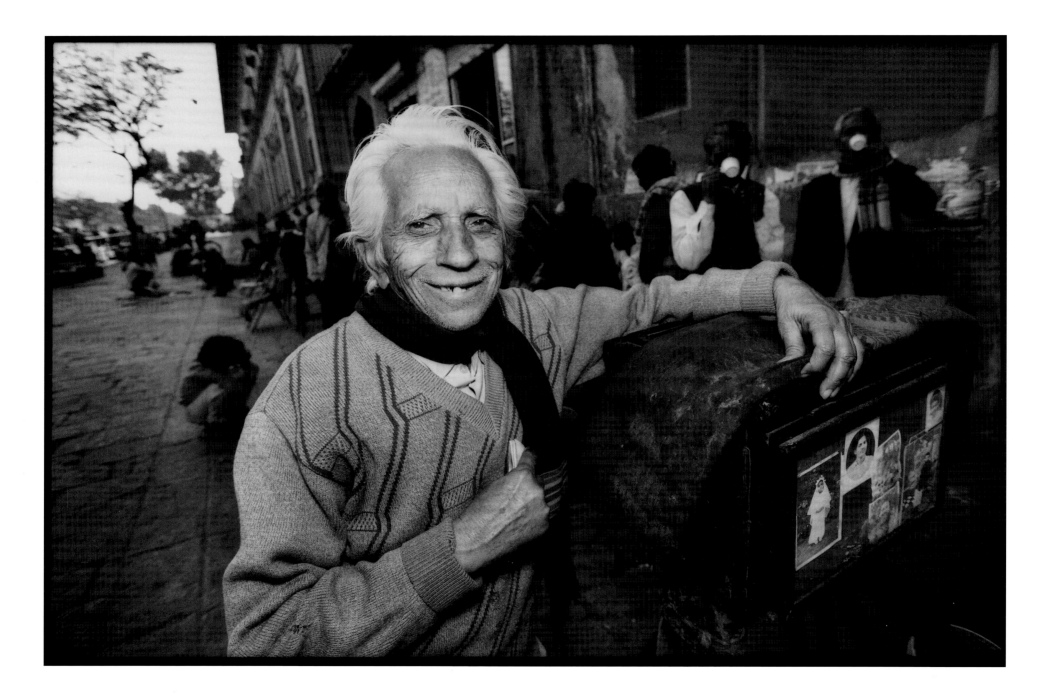

Street Photographer – *INDIA*

 When I shoot, I attempt to create a relationship between the subject and their environment with the composition and the visual atmosphere I find at the moment. In this portrait an Indian street photographer shot of me, he took a more direct approach: "Please sit, look to camera, don't move." Max

MAX: This is a perfect example of how taking someone's portrait is like tossing a pebble in a pond. This street photographer in Jaipur and I shared shop talk and took each other's pictures. The following year, a friend of mine visited India and took this photo to give to the photographer, if she could find him. She did, and returned with a photo of the two of them holding my original photograph.

BD: You can see his pride in all the portraits he's shot over the years. His photography has touched many people at their most important moments.

"...a quick **Las Vegas** wedding..."

MAX: This British couple had just had a quick Las Vegas wedding and loved the idea of posing for a picture. Something real they could cherish from the mirage that is Las Vegas.

BD: But their enjoyment is very real. The whole world loves to come to Las Vegas. It's not emblematic of any culture. It's just a place to have fun.

MAX: And make fun of culture, really.

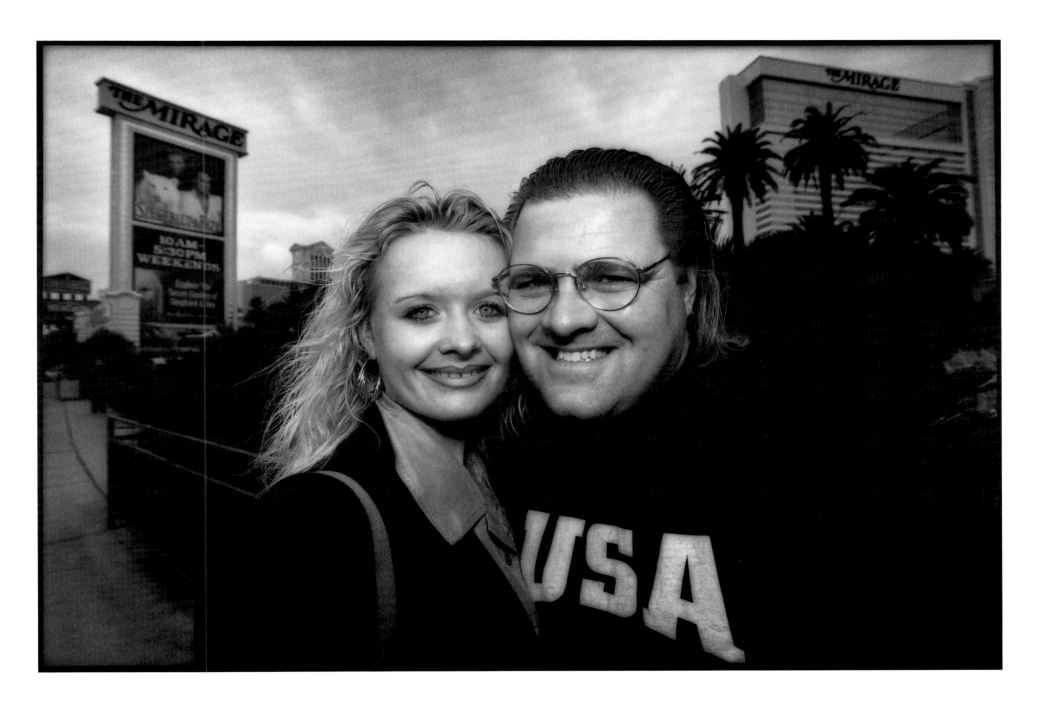

Newly Married Couple – *LAS VEGAS*

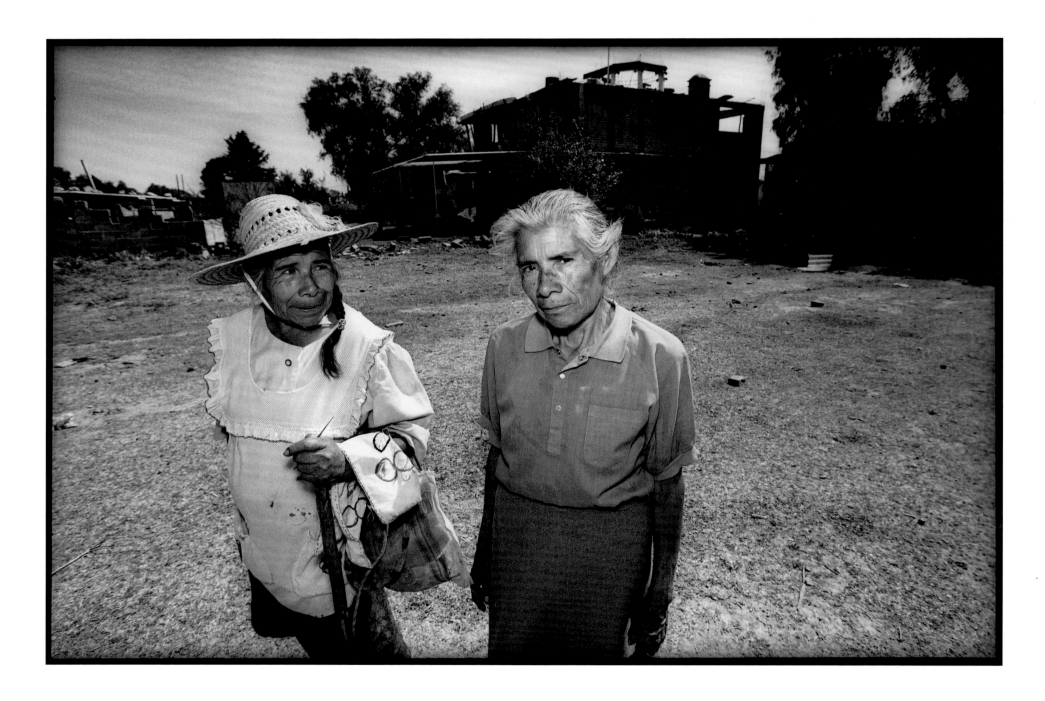

Two Farm Women – *MEXICO*

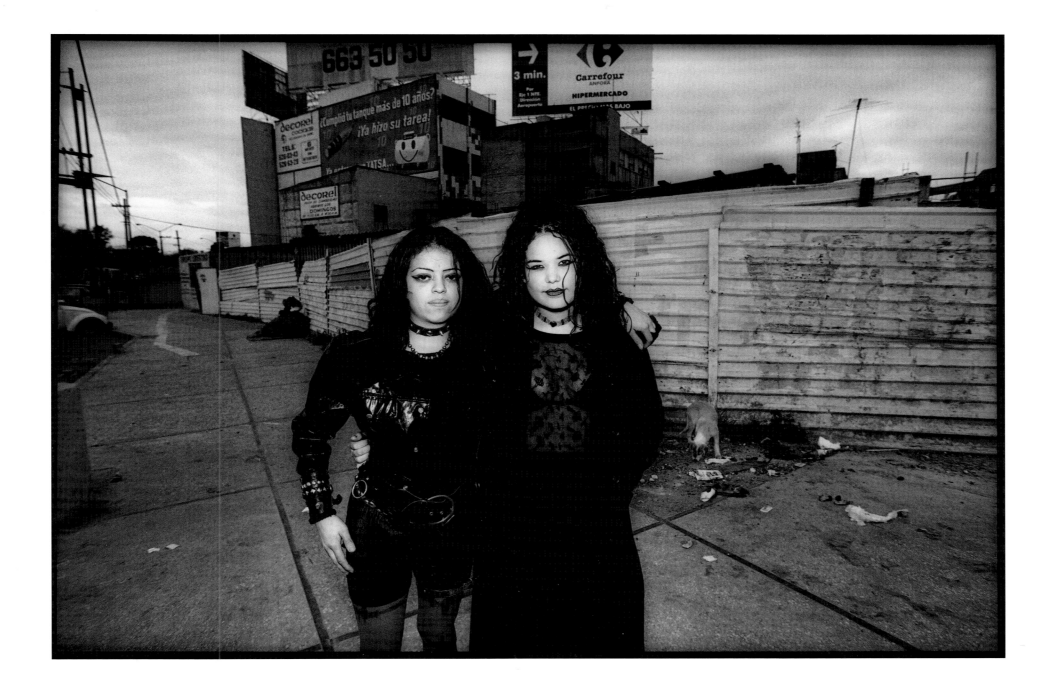

Girls in Black – *MEXICO CITY*

MAX: What got to me was the matter-of-factness of these women, like I'd caught them in a mall parking lot.

BD: Their expressions are so neutral. They communicate reams with their outfits and absolutely nothing with their faces.

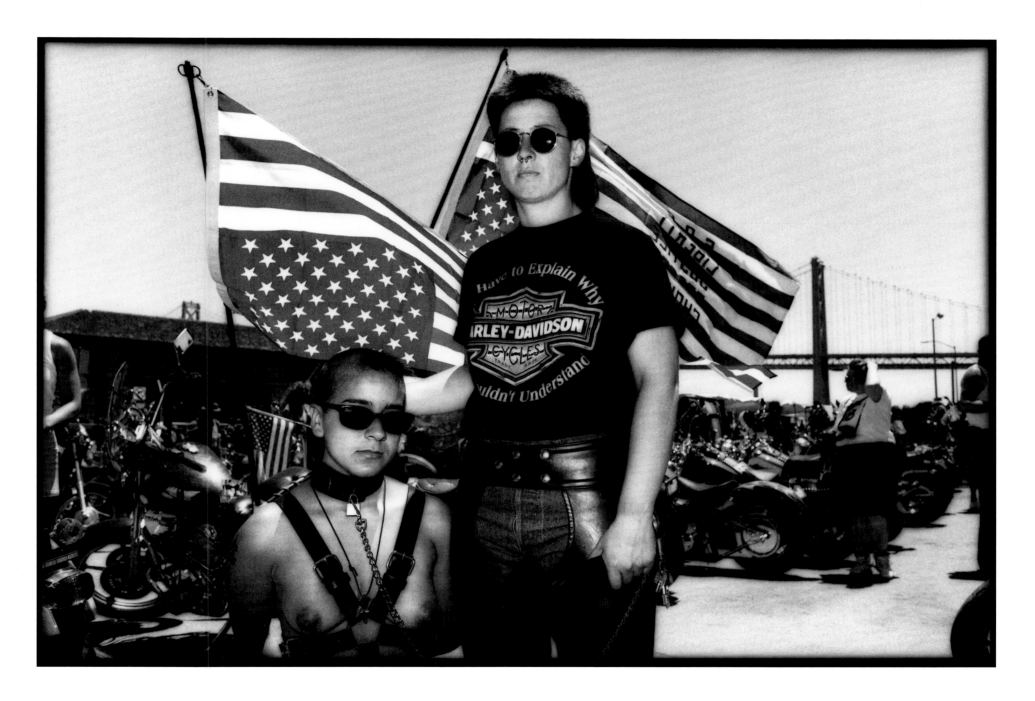

After the Ride – *SAN FRANCISCO*

MAX: We couldn't verbally communicate, but he took me along to the park where he met up with other bird fanciers.

BD: I suppose walking your bird is better than not walking your bird. But isn't flying supposed to fit in somewhere?

MAX: Actually, everyone—men and birds—seemed to be enjoying themselves a lot.

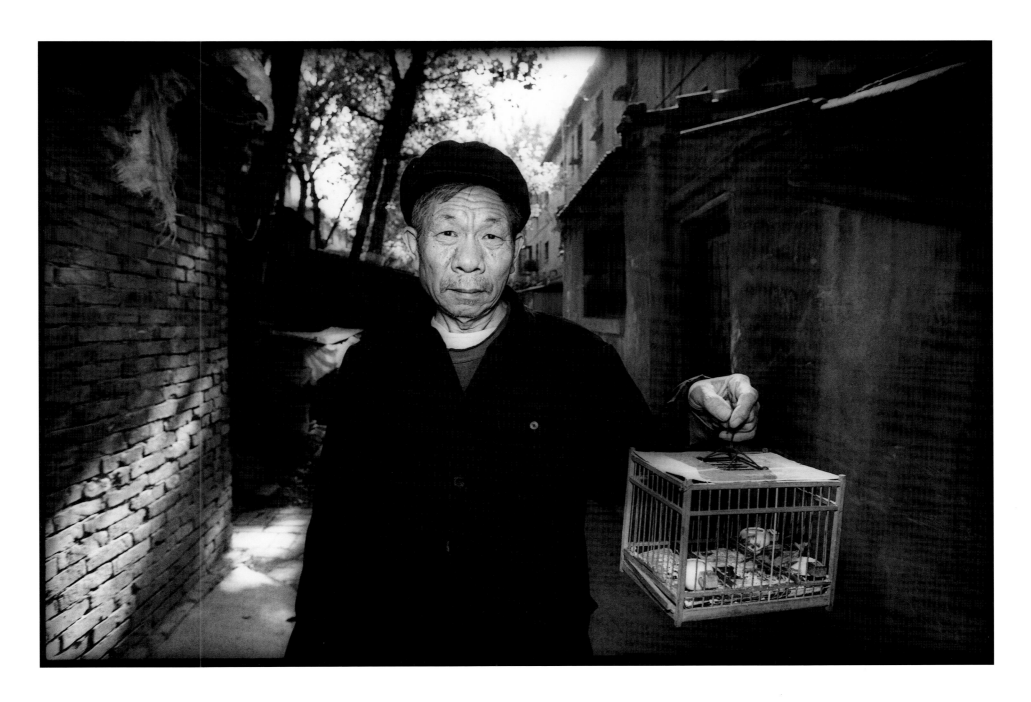

Man Walking Bird – *BEIJING*

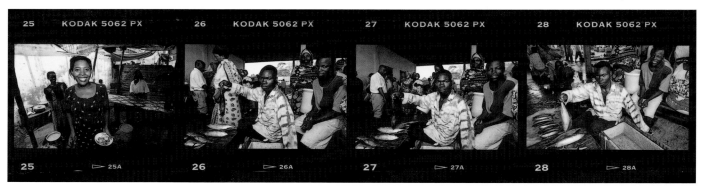

MAX: I must admit that photography doesn't always communicate everything. This huge fish market in the hot tropical sun smelled to high heaven.

BD: Thanks, Max! For once, I'm not envying one of your exotic times abroad.

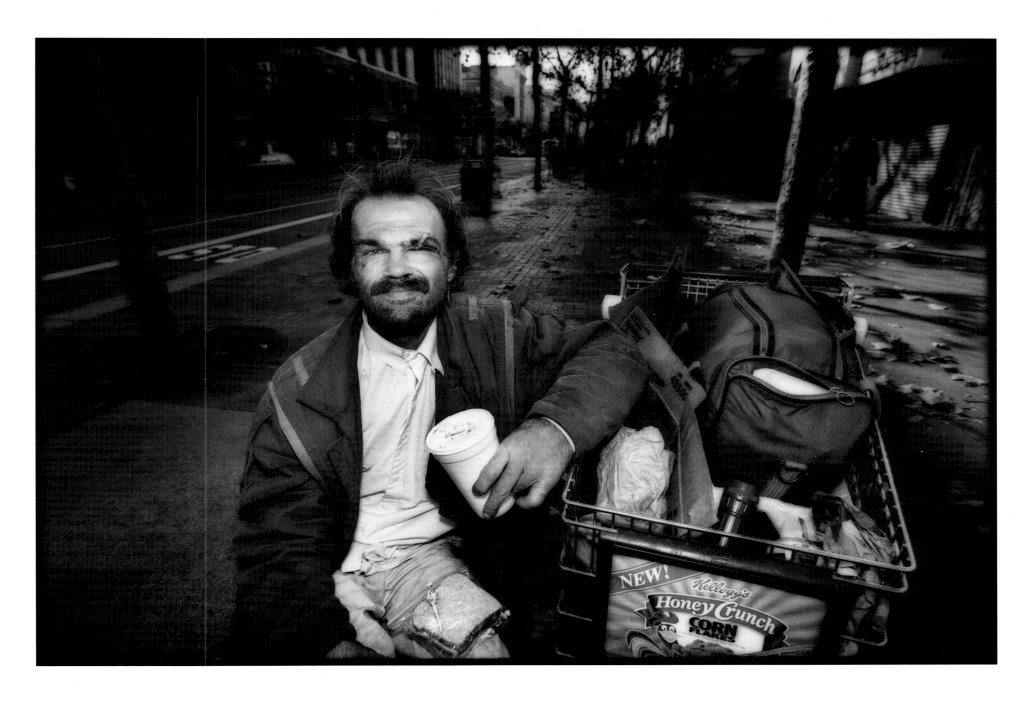

Man on Market Street – *SAN FRANCISCO*

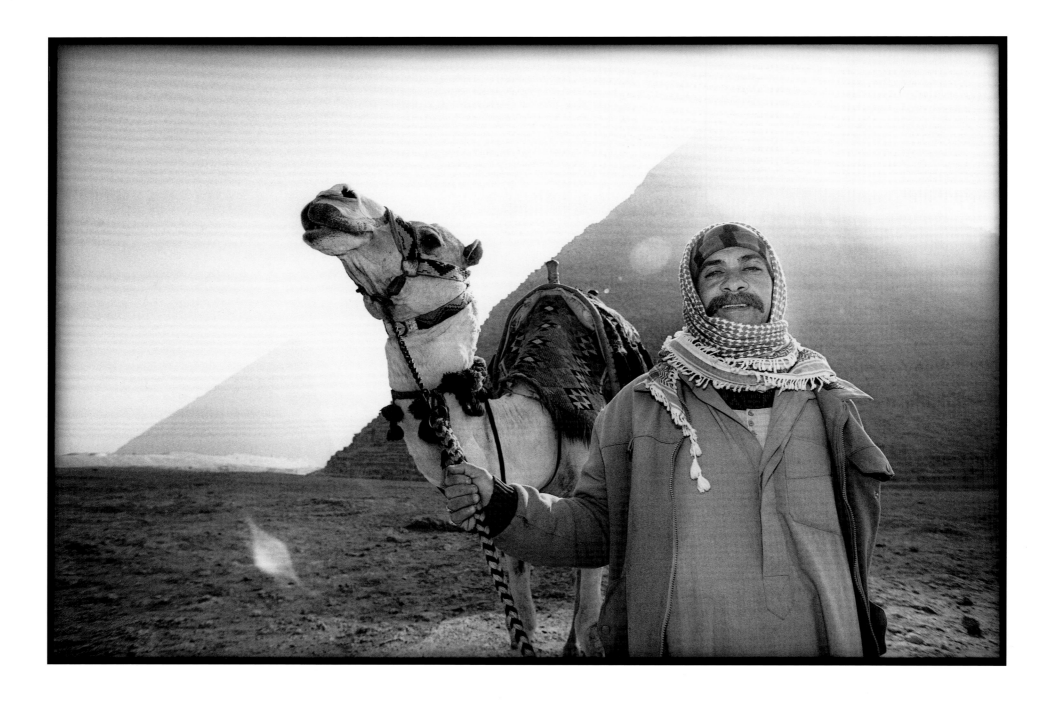

Sabre's Camel, Giza – *EGYPT*

"What's the harm?"

BD: It's the poison of mass tourism. Instead of herding camels or transporting goods across the desert, this man is now a parody of himself, posing with tourists in front of the Pyramids.

MAX: The guy earns an honest living. He's communicating what's left of his culture to visitors from around the world. What's the harm?

BD: This man looks both defiant and resigned, like he has the history of Mexico in his eyes.

MAX: This was a very tense standoff between ranchers and the Guadalajara police. They had taken over the State Capitol Building and set up barricades, even using their animals to block entrances.

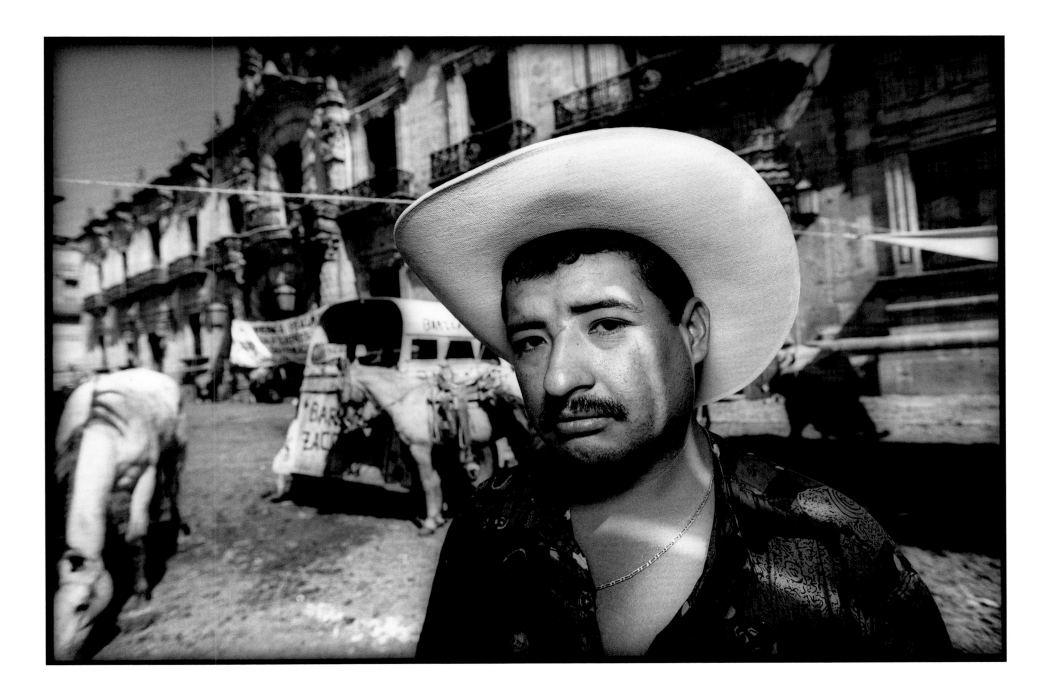

Protesting Rancher – *GUADALAJARA*

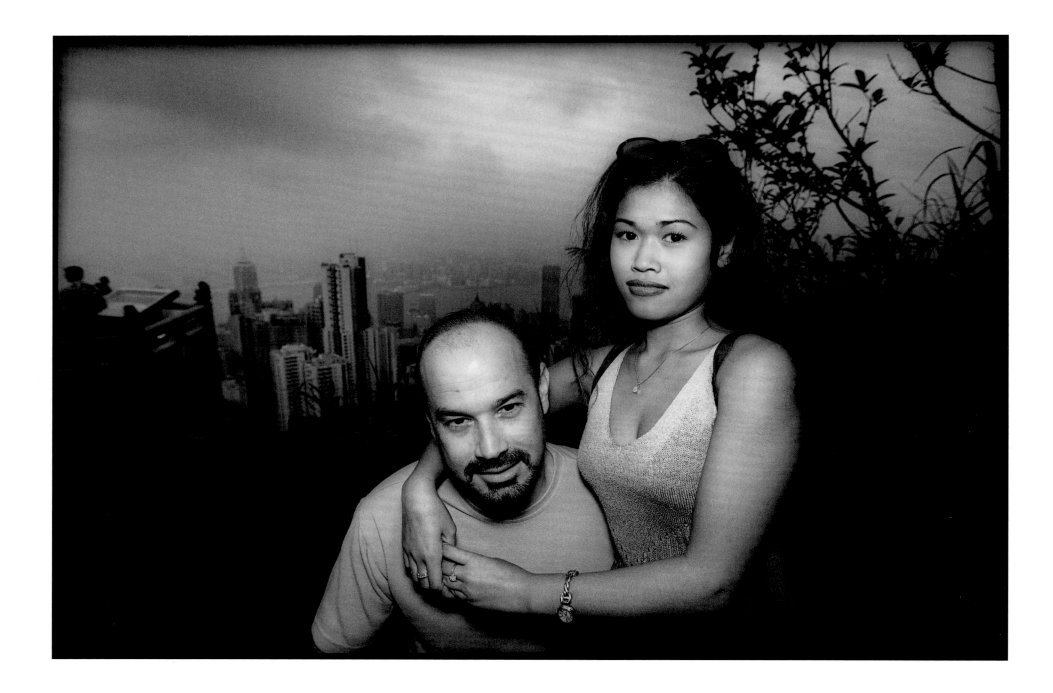

Victoria Peak View – *HONG KONG*

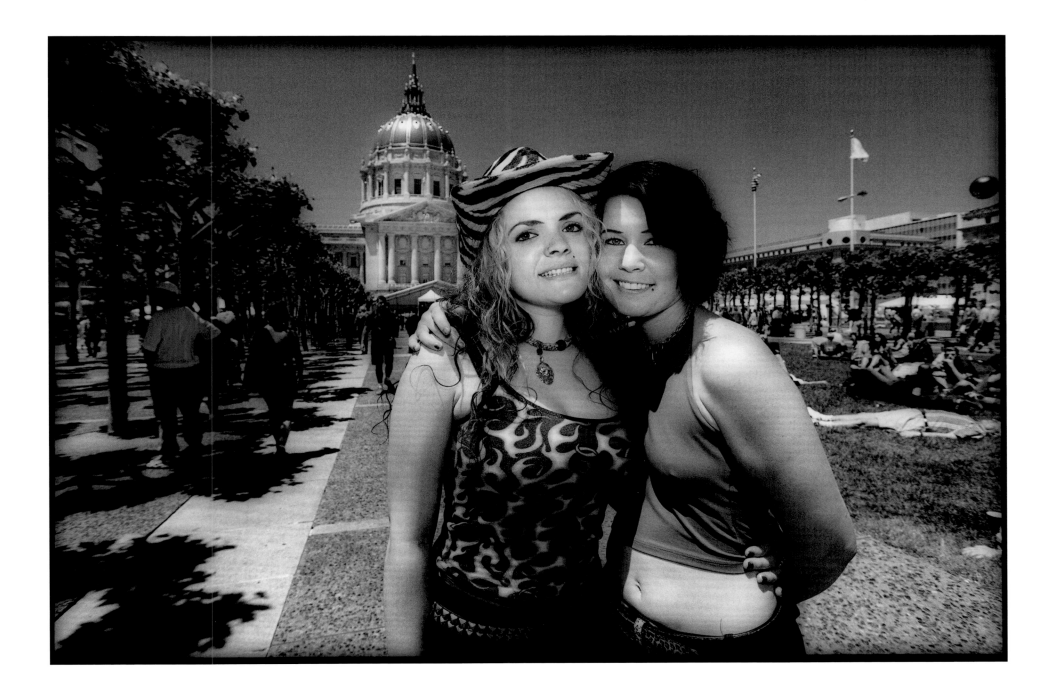

City Hall – *SAN FRANCISCO*

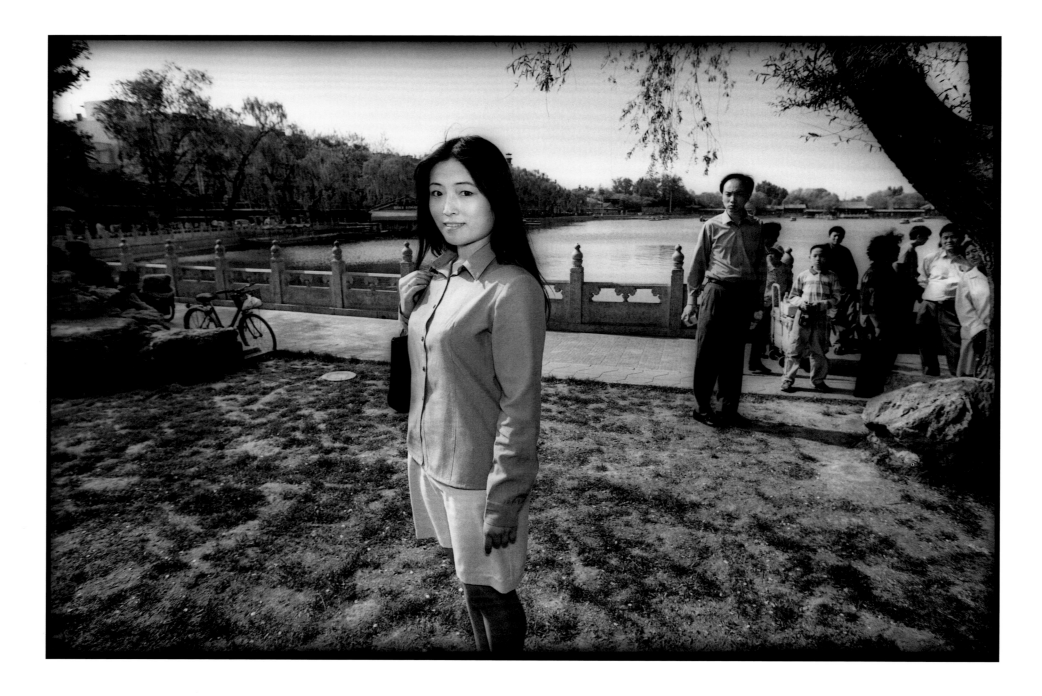

Woman in Park – *BEIJING*

MAX: When you approach someone, you never know what the reaction will be. In this case, this seemingly free-spirited young woman was pleased to pose. Her companion was anything but pleased! And a few people even hid behind the tree.

BD: Isn't it interesting how different people—regardless of culture—respond to an encounter with a stranger?

MAX: Everyone seems to loves beauty queens on parade. It's universal.

BD: I love seeing the Ferry Building in the background. The girls' parents or grandparents may have arrived right there looking for a new life. And good or bad, they certainly found it.

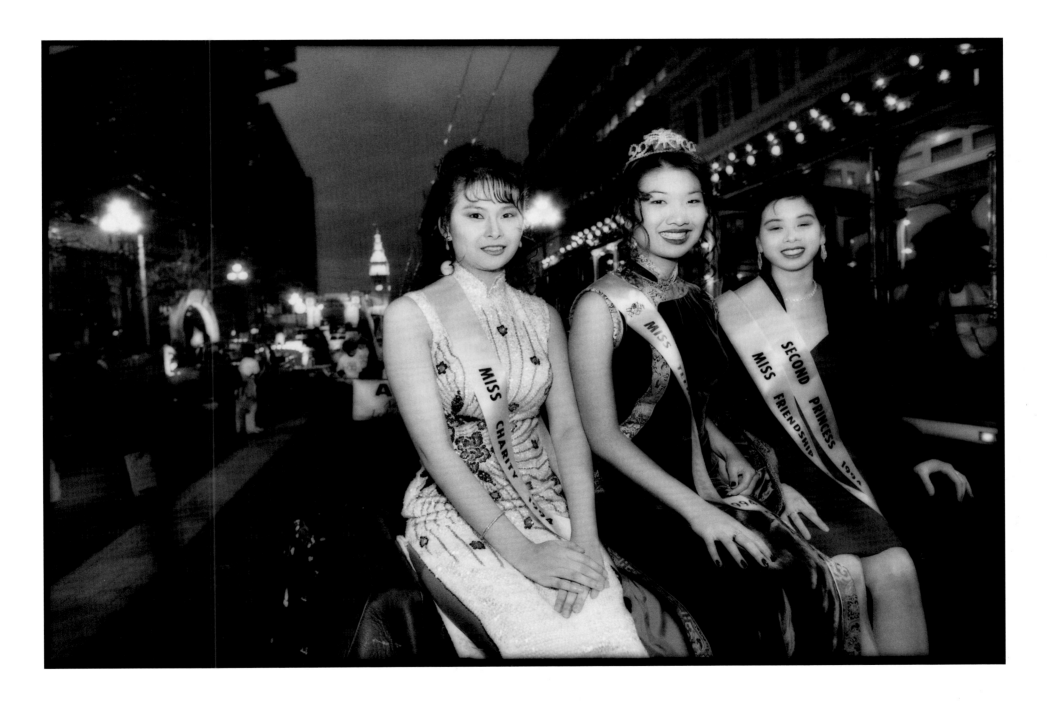

Three Queens – *SAN FRANCISCO*

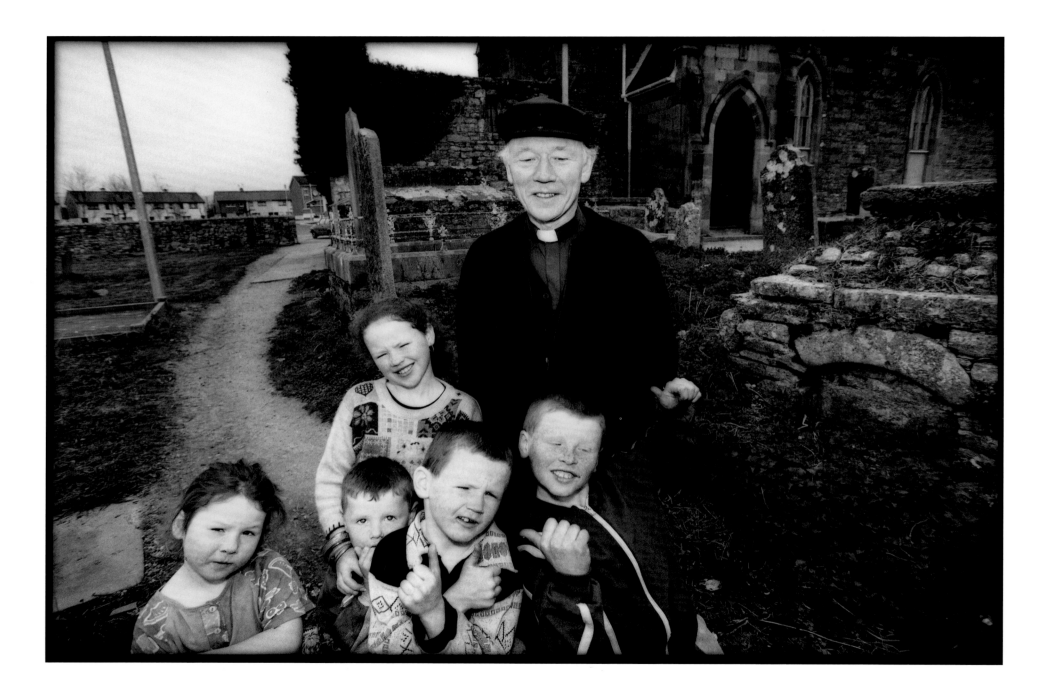

Priest with Children – *IRELAND*

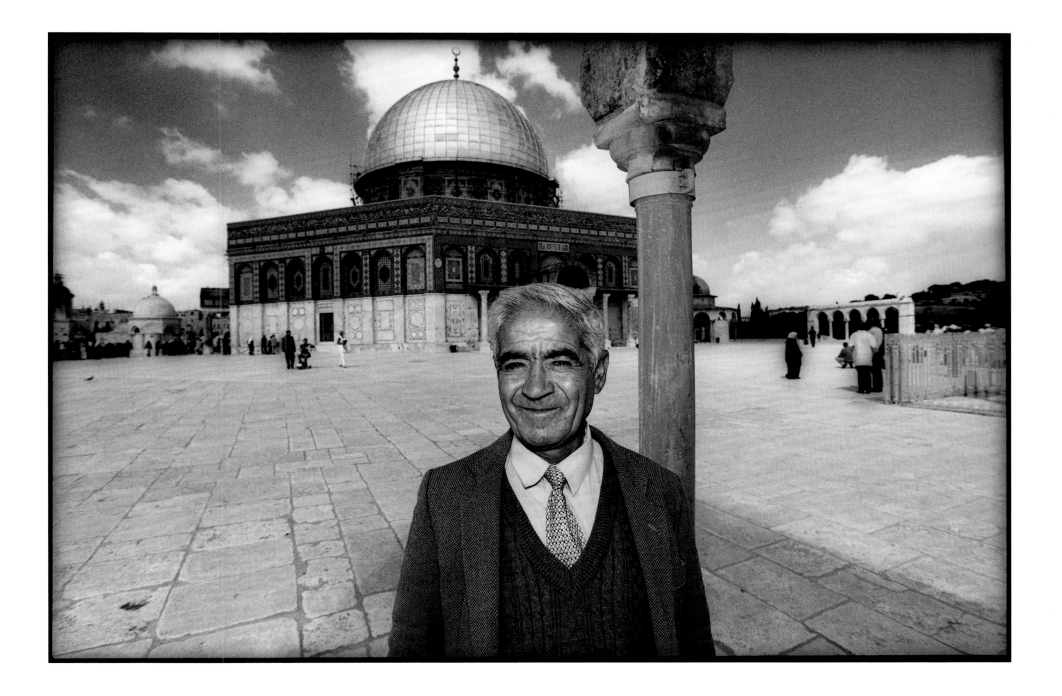

Dome of the Rock – *JERUSALEM*

"I have a great curiosity about people—I want to learn about them, at least a bit, to bring back a two-dimensional image to share with others. And if they happen to be like this Maasai elder, then the more curious I become."

Max

MAX: This Maasai elder touched my camera and nodded yes.

BD: With no other means of communication, the camera gave you a human connection—which I know is why you take pictures in the first place.

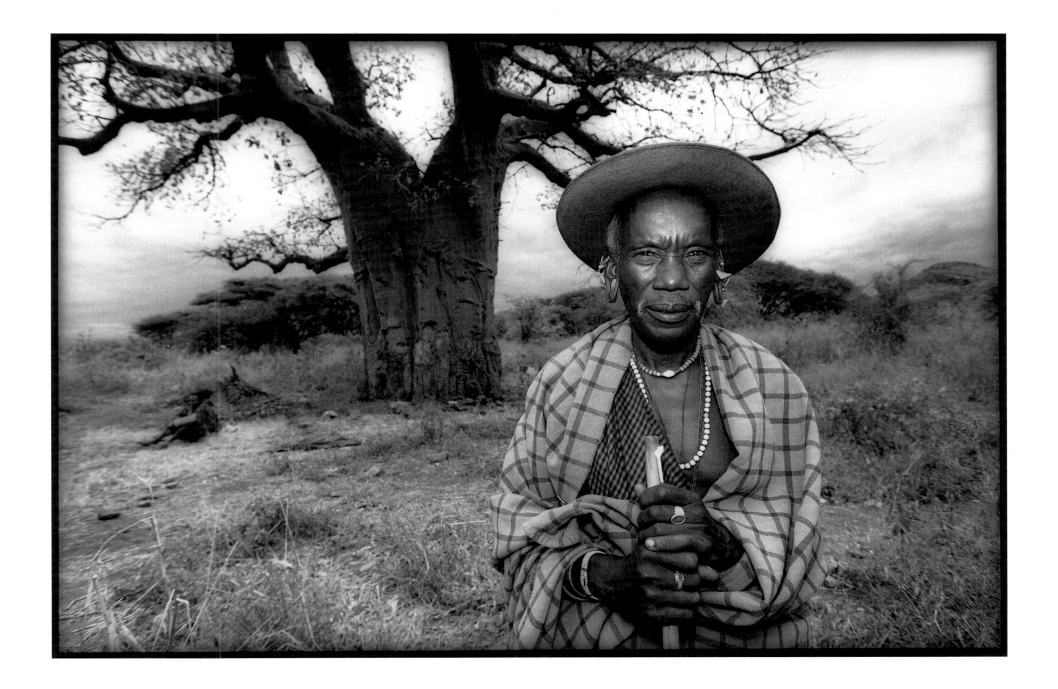

Maasai Elder – *TANZANIA*

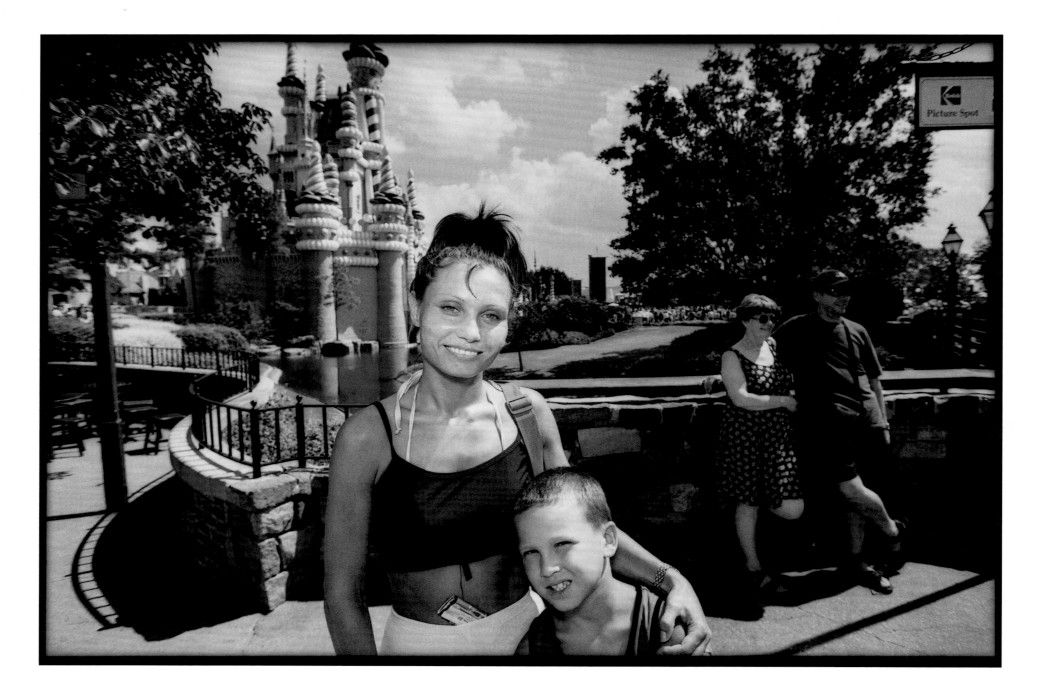

Mother and Son, Disney World – *FLORIDA*

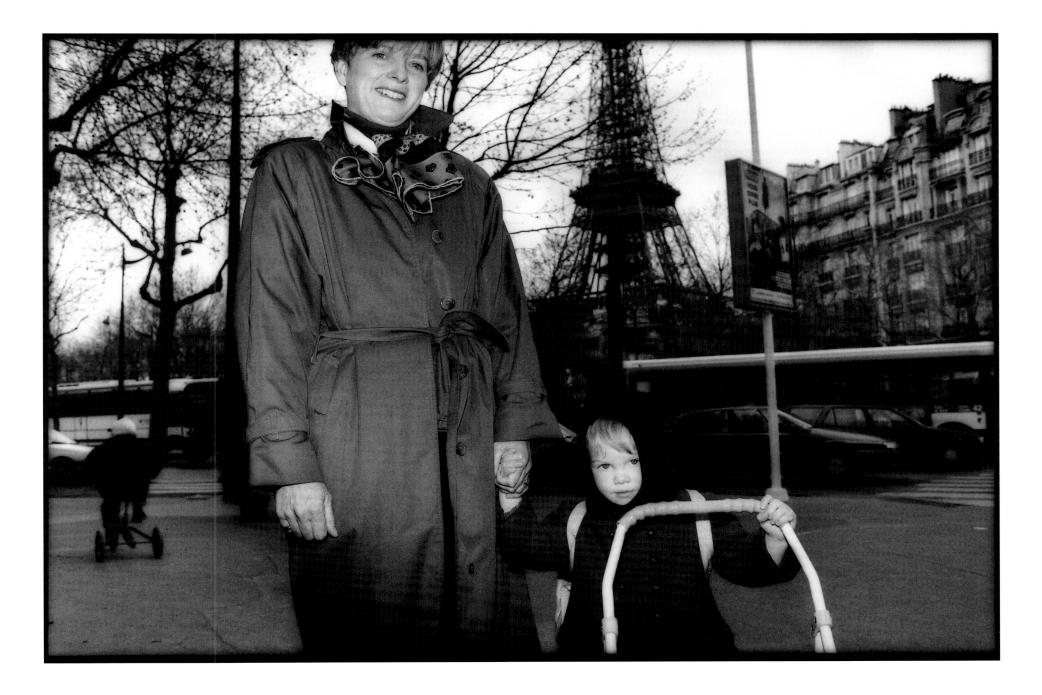

Mother and Daughter – *PARIS*

MAX: The weekend beach crowd and the amusement park were all noisy activity. For him though, it was all peace and calm.

BD: Also for that little seagull in the corner.

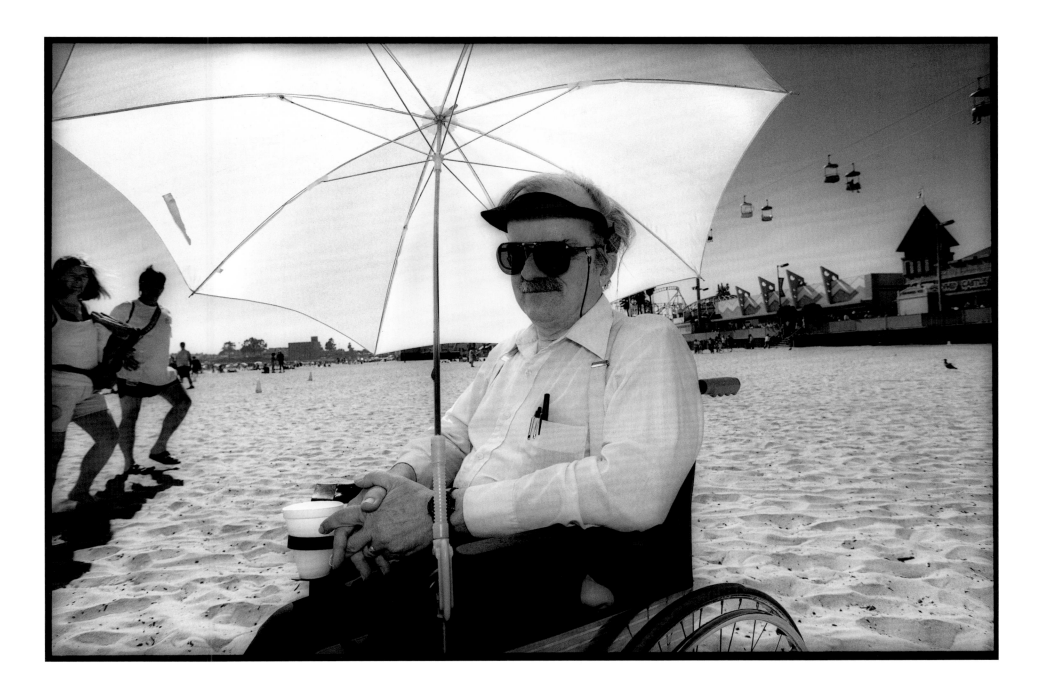

Man on Beach – *CALIFORNIA*

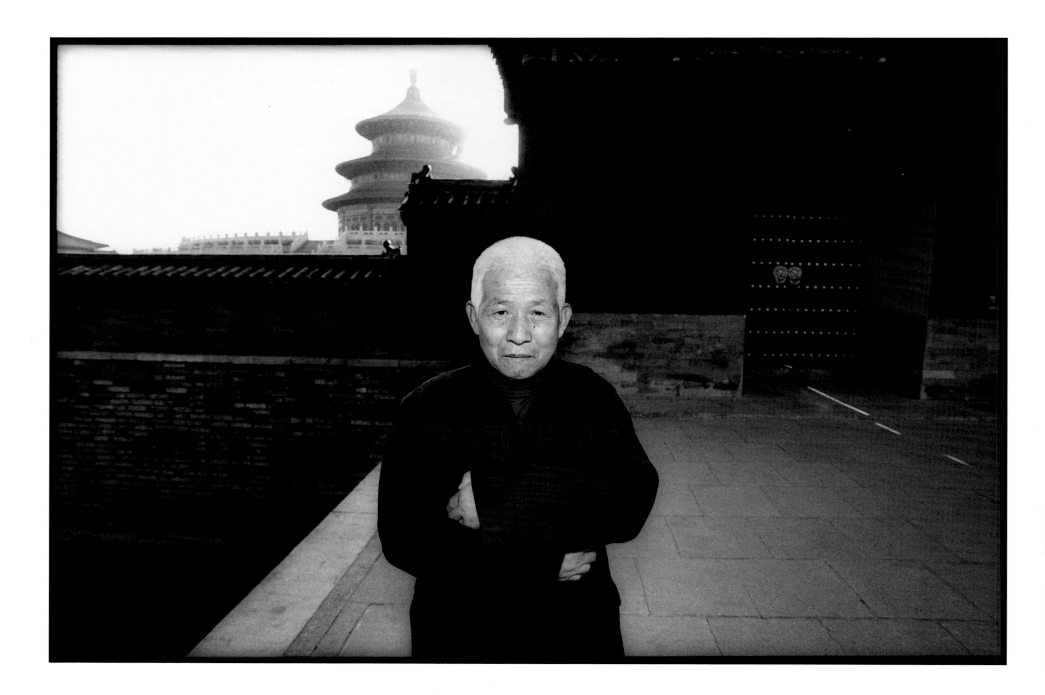

Tiantan Park – *BEIJING*

BD: It feels like this photo was taken a thousand years ago.

MAX: I wonder which Dynasty? Actually, this gentleman took a pause in his early morning exercises to point out the various activities happening around us. There was tai chi, gongfu, kite flying, walking backwards up and down stairs, and yes, ballroom dancing in this park at 7:am!

"We can learn so much about an individual, and their culture, when we interact with them via the photographic experience. And they might just adjust their attitude towards us when they see the results of the encounter! Taking the time to get an address and sending them a print completes the communication."

Max

MAX: This retired professor had stories to tell, and I listened. He'd seen a lot of Irish history pass through Trinity's portals.

BD: You can see it in his soft, knowing eyes!

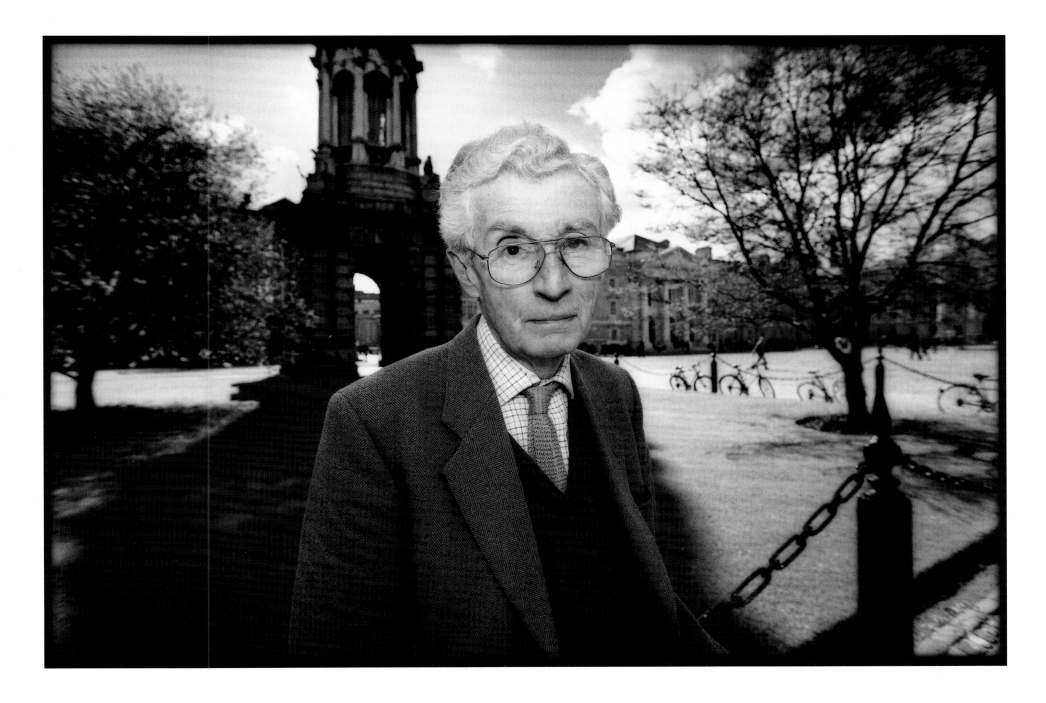

Trinity College, Dublin – *IRELAND*

BD: This captain looks like he's been there forever while the modern world sprang up all around him.

MAX: He gave me the tiller briefly, and both of us actually lived to tell about it. It wasn't as simple as I thought!

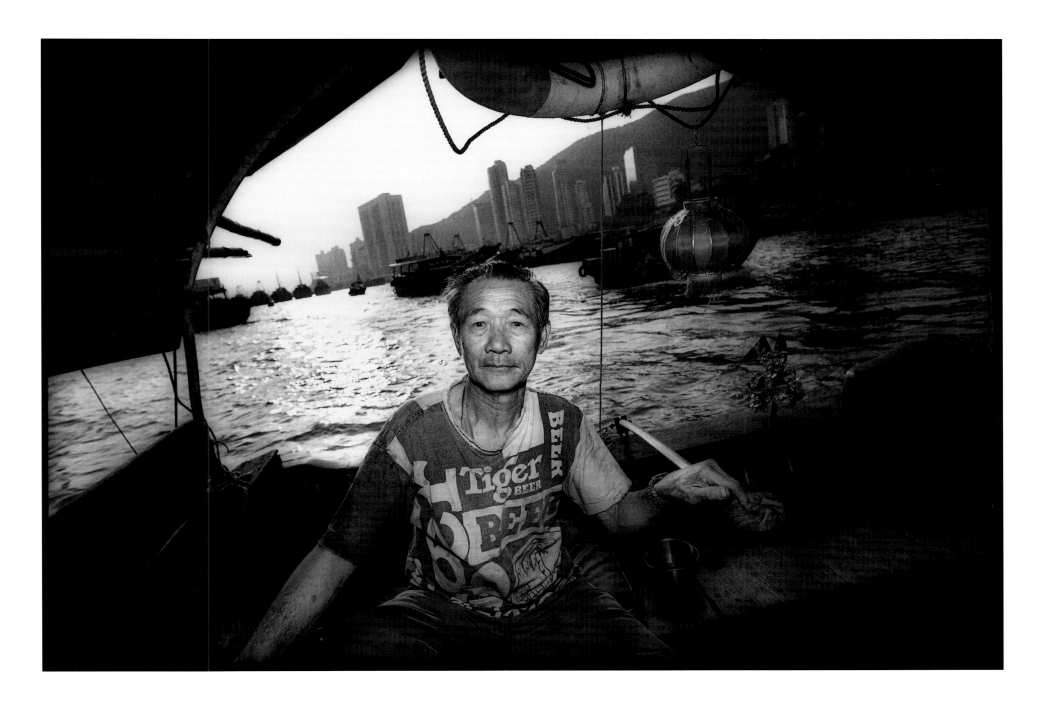

Sampan Captain – *HONG KONG*

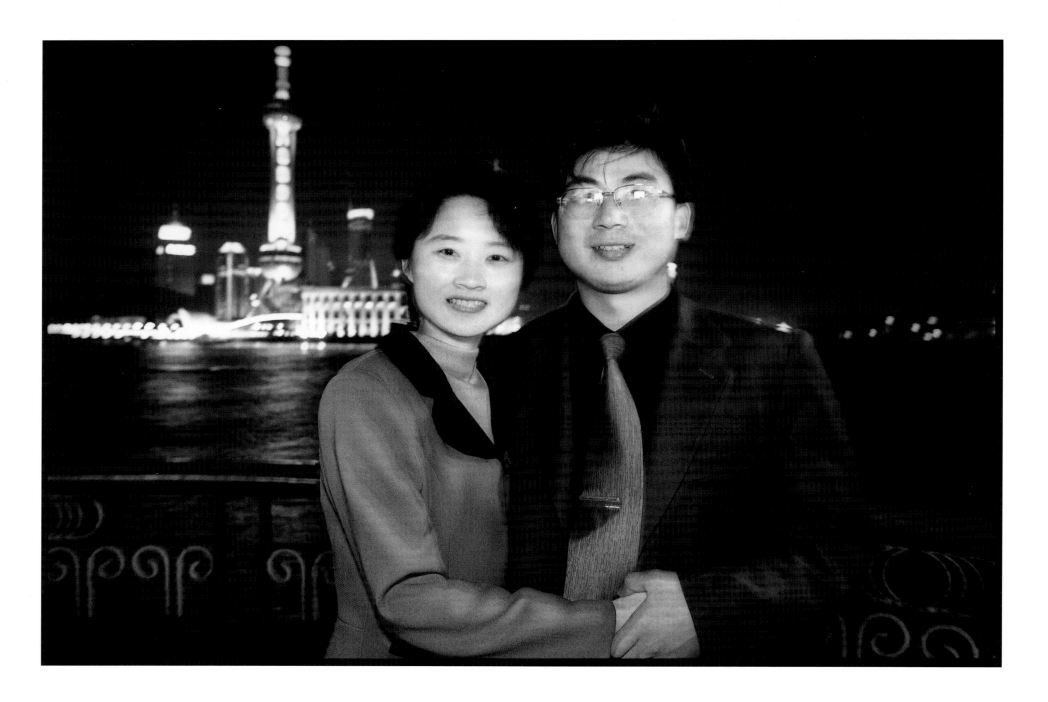

May Day Celebrants – *SHANGHAI*

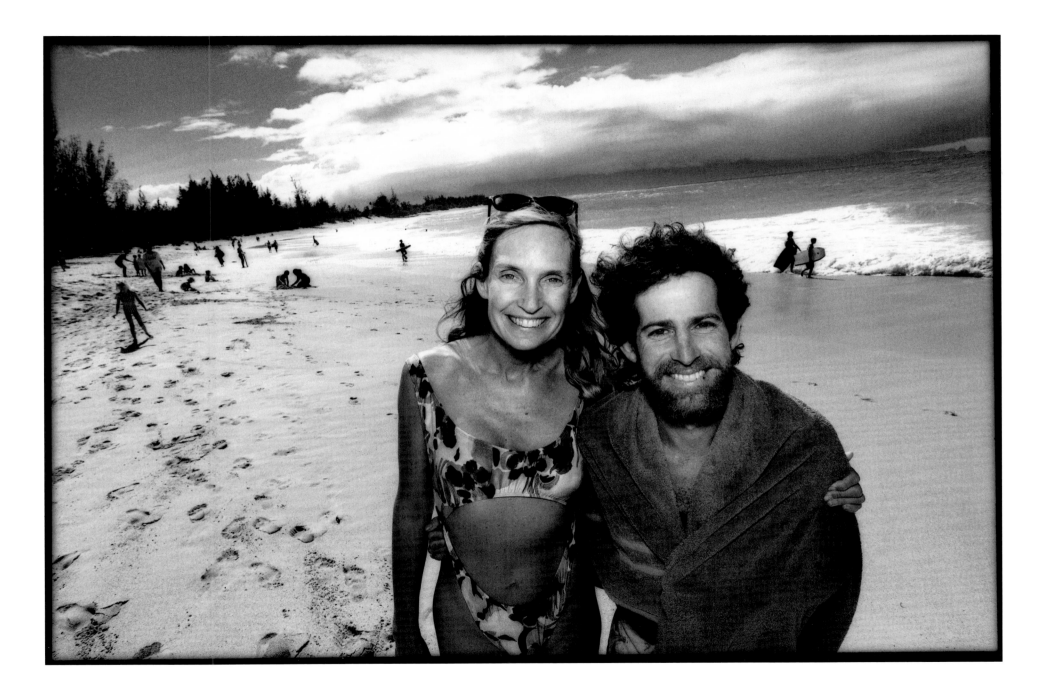

Beach Couple, Maui – *HAWAII*

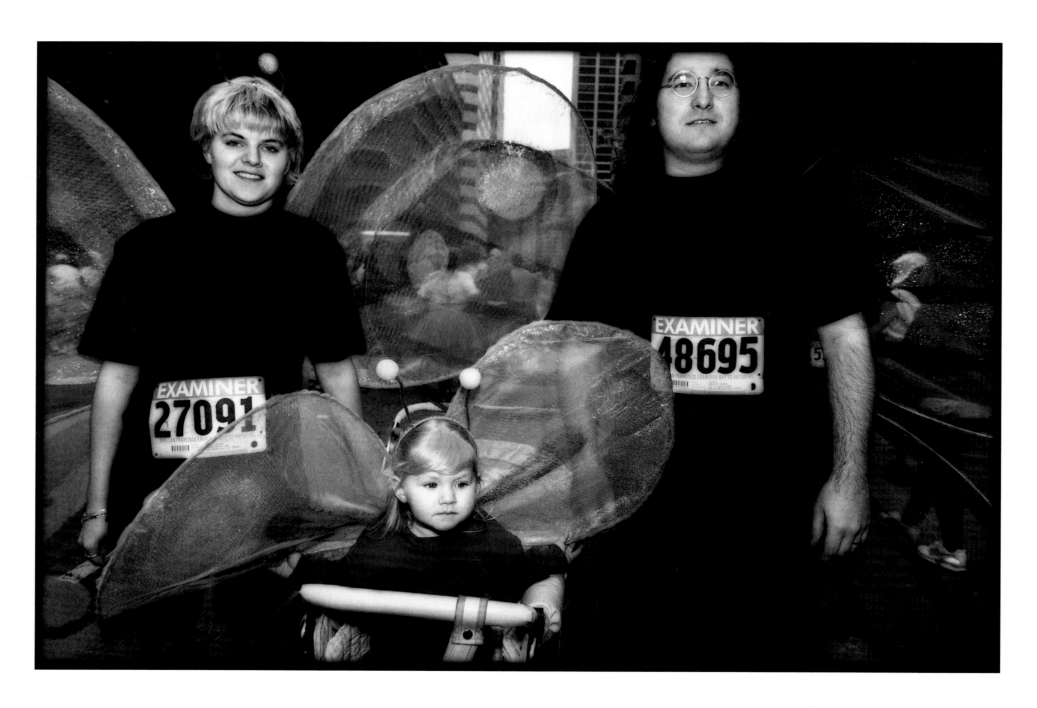

Bay to Breakers Race – *SAN FRANCISCO*

MAX: In this race, winning isn't everything. Creativity is.

BD: Refreshing, isn't it? No doping. Just dopiness.

BD: Two angel faces in a sea of manly machinery.

MAX: You never know what you'll find unless you look, and then look again!

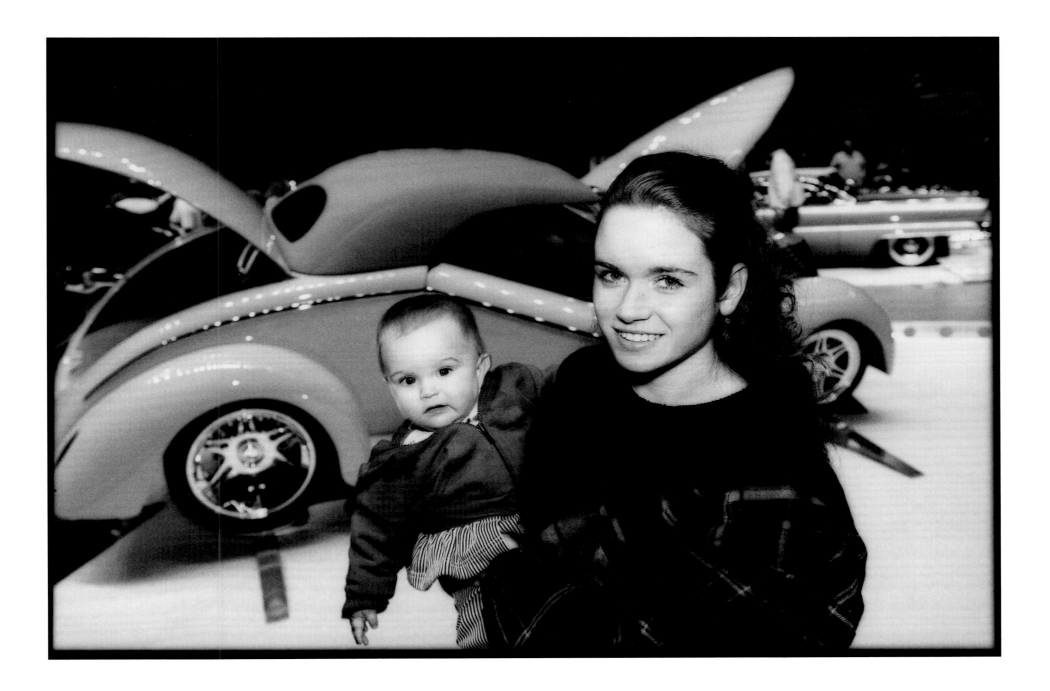

Auto Show, Oakland – *CALIFORNIA*

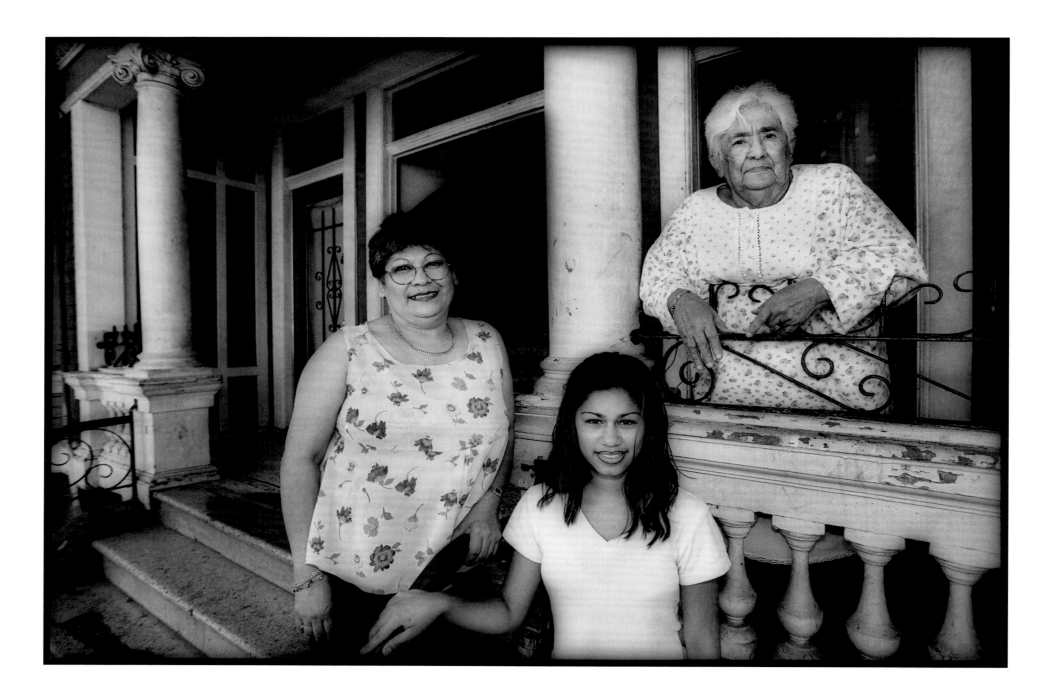

Mission District Family – *SAN FRANCISCO*

BD: Different generations, extended families, old cultures blending with the new.

MAX: It's the story of America—and you can see it in their faces.

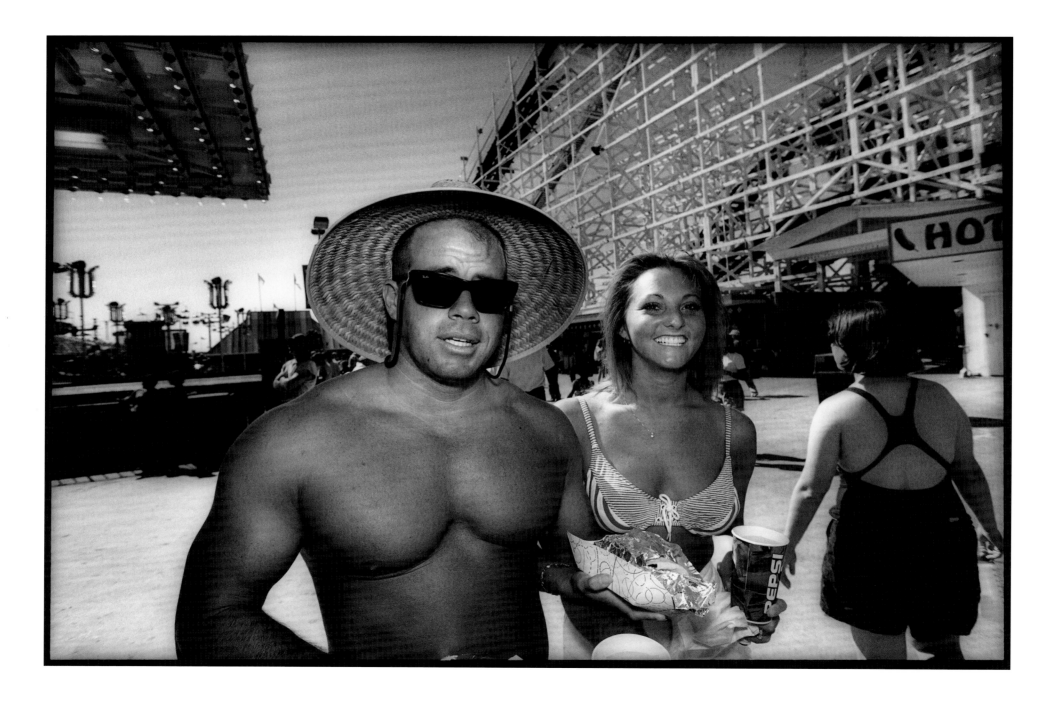

Santa Cruz Boardwalk – *CALIFORNIA*

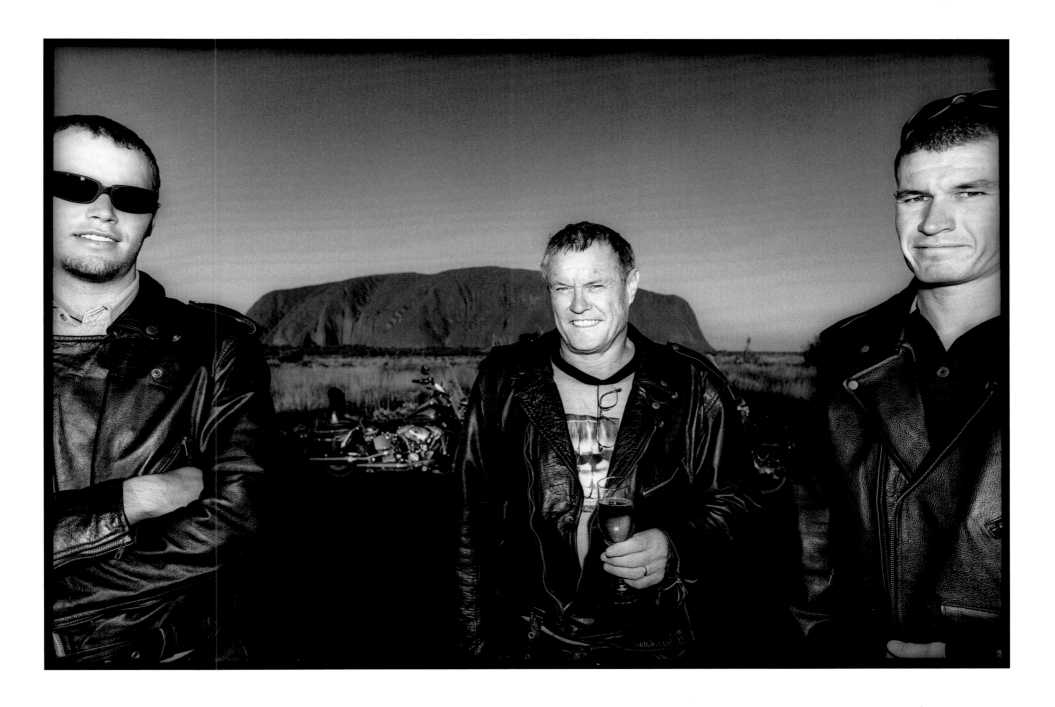

Ayers Rock Sunset – *AUSTRALIA*

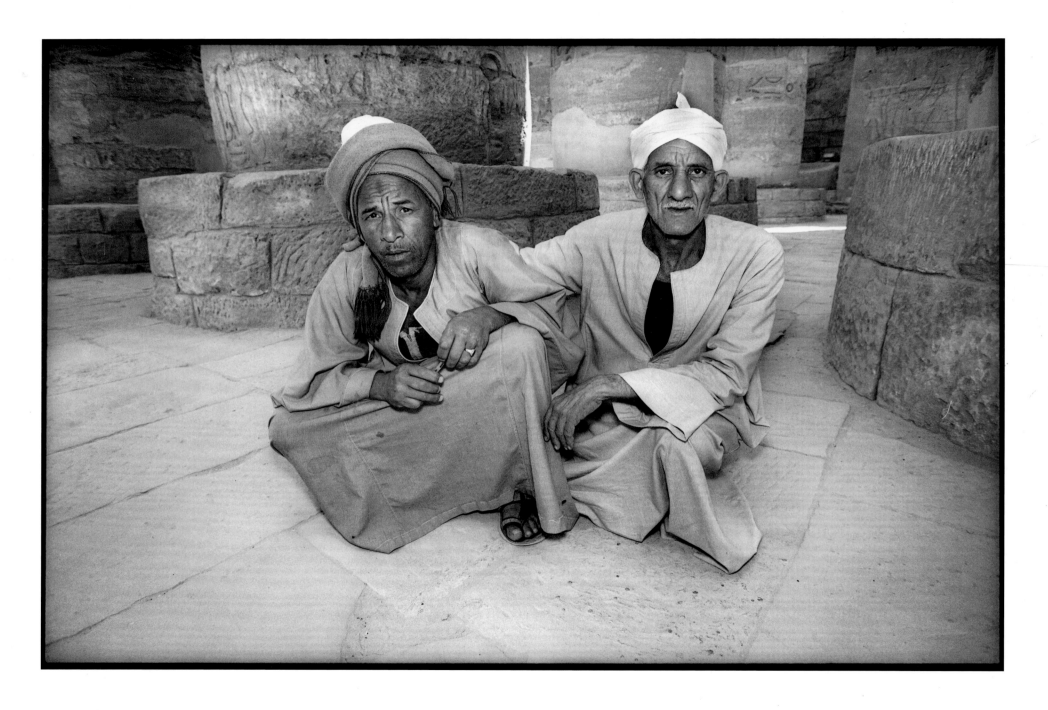

Men in Temple, Luxor – *EGYPT*

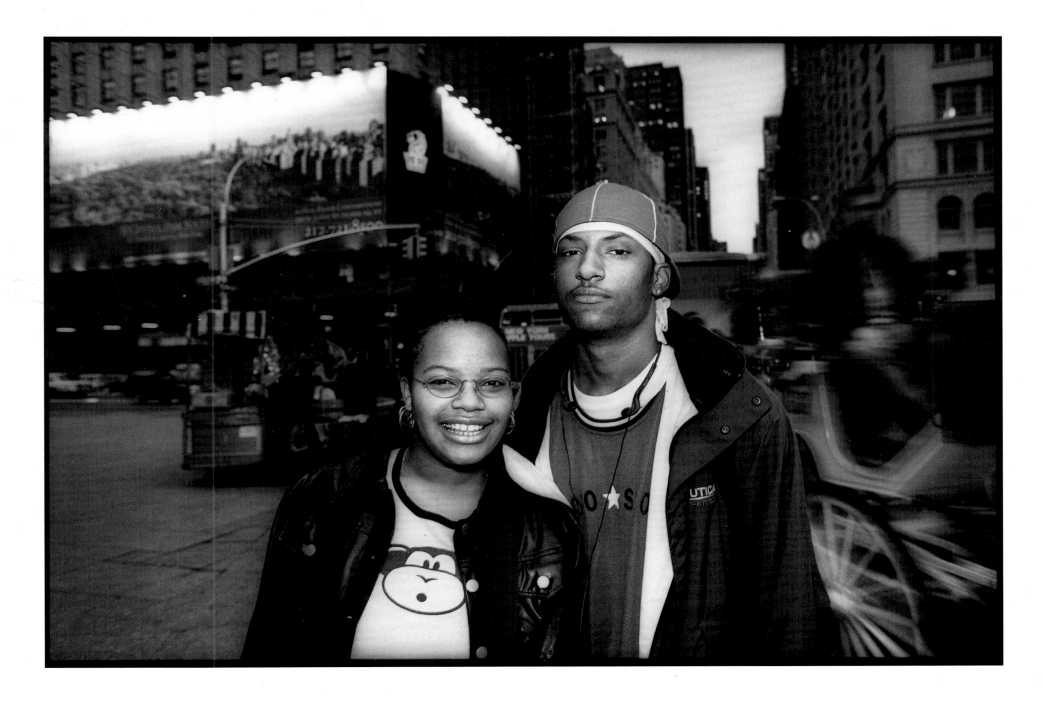

Young Couple Posing – *NEW YORK*

MAX: Can a camera create friendships? This one did in five minutes between me, a South African actress and a native New Yorker.

BD: Globalization, Max-style.

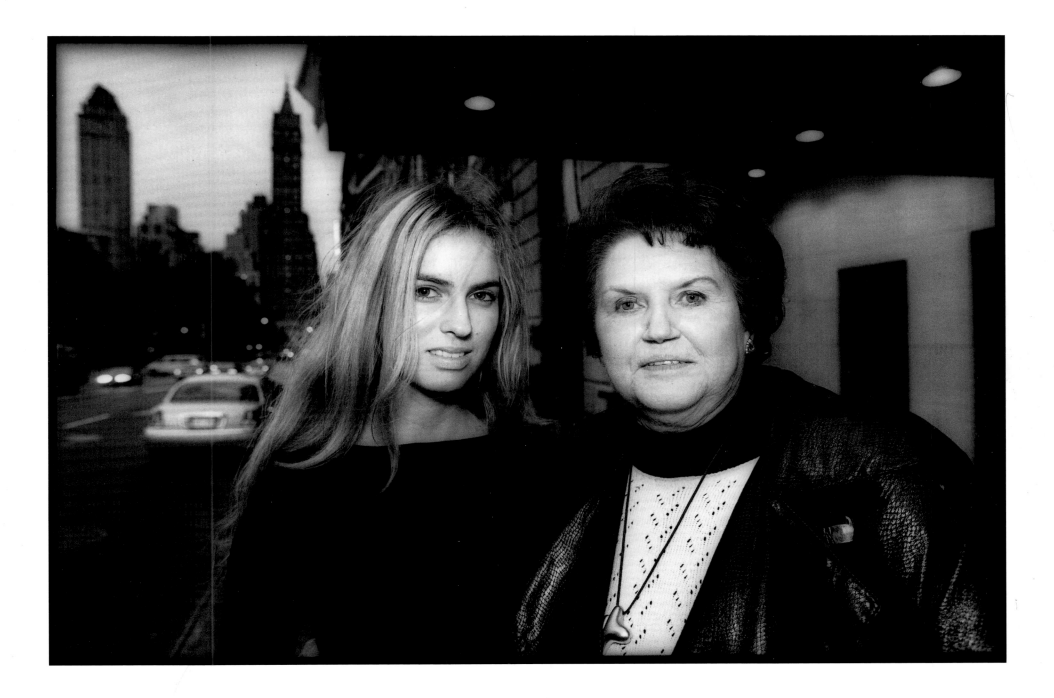

Central Park South – *NEW YORK*

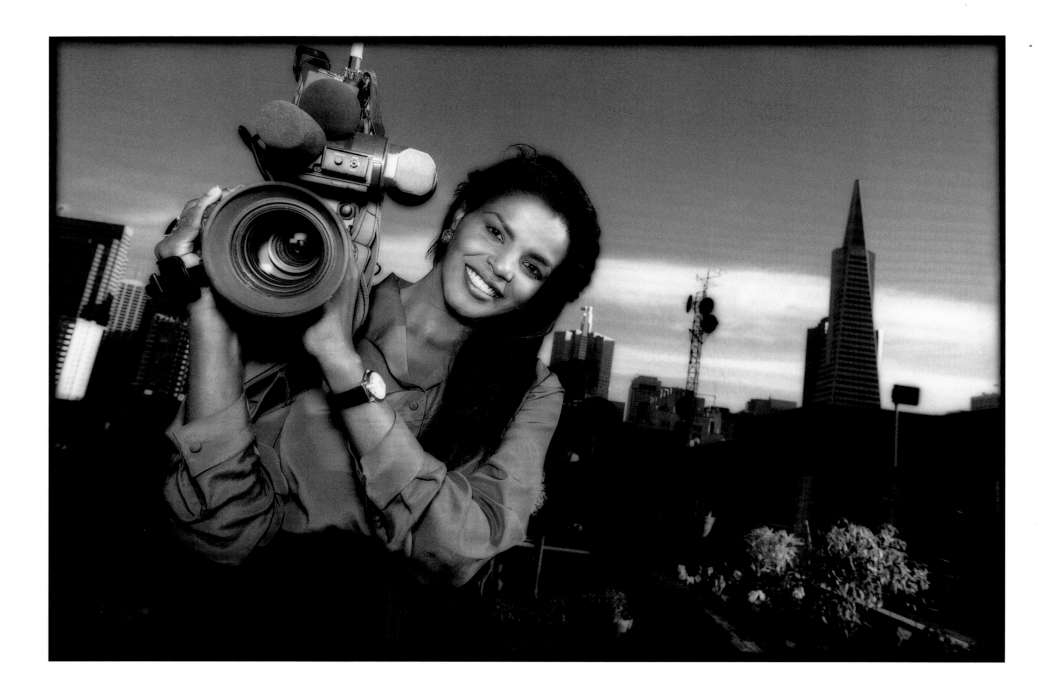

TV Camerawoman – *SAN FRANCISCO*

BD: I love seeing her come out from her observer role and flash that big smile.

MAX: Yeah, she could get anyone to open up, in spite of that huge video camera.

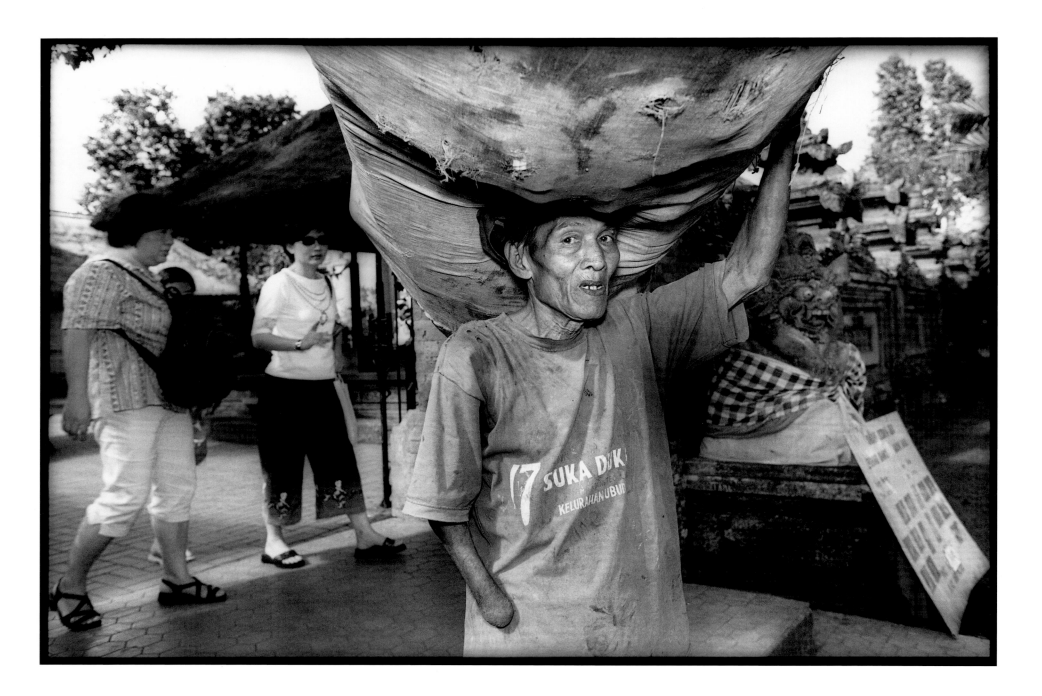

Man Carrying Bundle, Ibud – *BALI*

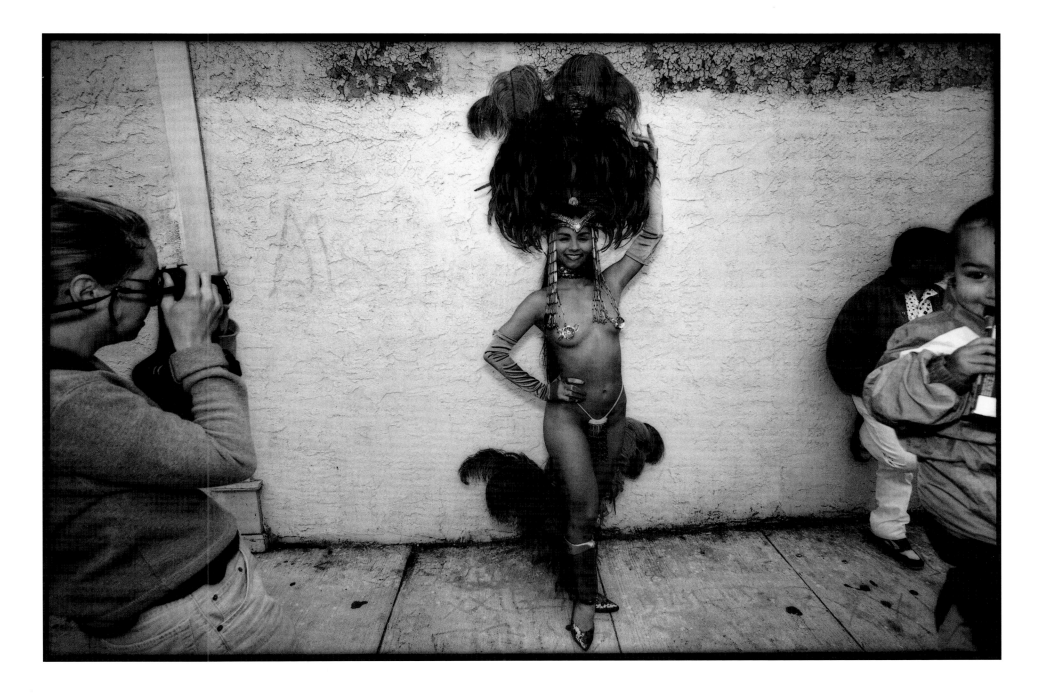

Carnival Parade Pose – *SAN FRANCISCO*

MAX: Just a normal portrait becomes mysterious in the heavy fog.

BD: That's the secret of San Francisco's allure—if you're wearing your ski parka in July.

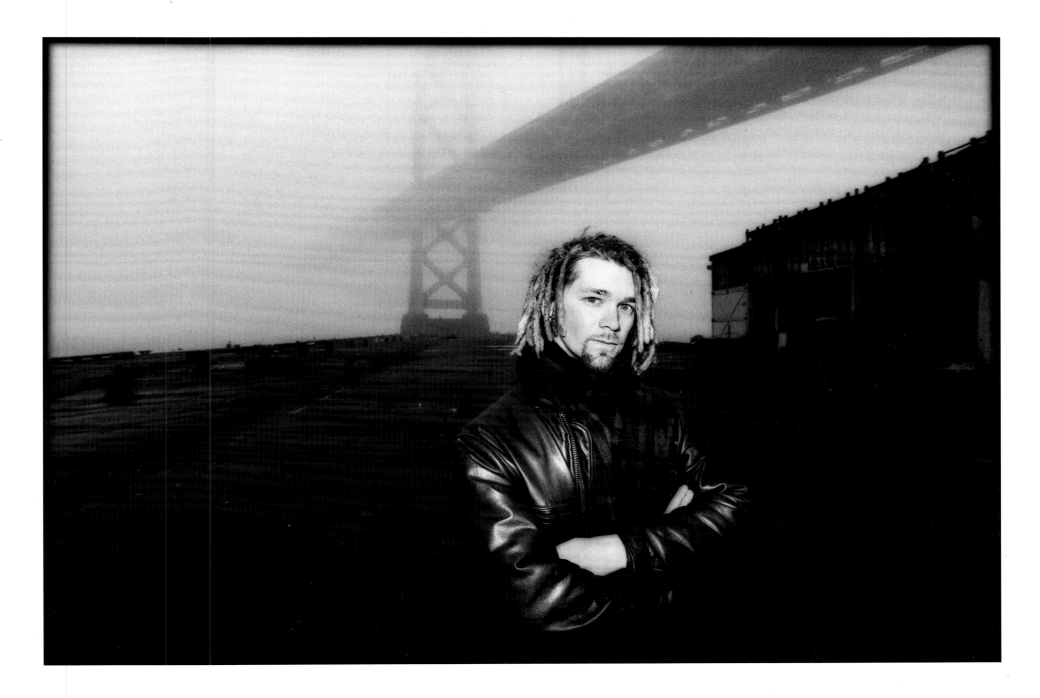

Heavy Fog – *SAN FRANCISCO*

THANK YOU

Special thanks to:

Basquali, Kevin Brown, Paul Curtin, Barbara Deutsch, Helen Land,

Vilija Marshall, Peg Oberste, Rich & Jeff, Shui Wong

and to all those who said, yes.

For inquiries about books and prints:
www.mustseebooks.com

Published by

MustSeeBooks

P.O. Box 320186
San Francisco, CA 94132

www.mustseebooks.com